Kodachrome
Milwaukee

Kodachrome Milwaukee

ADAM LEVIN

THE
History
PRESS

Published by The History Press
Charleston, SC
www.historypress.com

First published 2023

ISBN 9781540257475

Library of Congress Control Number: 2023932302

Notice: The information in this book is true and complete to the best of our knowledge. It is offered without guarantee on the part of the author or The History Press. The author and The History Press disclaim all liability in connection with the use of this book.

In memory of my father, Harvey Levin (1947–2020), and my grandfathers, Edmund Levin (1916–1976) and Leo Pinkert (1912–1998).

CONTENTS

1. Ray Szopieray Collection 9
2. State Fair Park's Milwaukee Mile Speedway 19
3. Legendary Brady Street 27
4. Milwaukee's German Fest 33
5. Milwaukee Basement Parties 39
6. Downtown Milwaukee Parades 47
7. Shriners Convention on Wisconsin Avenue 55
8. Milwaukee Arena (Milwaukee Bucks) 61
9. Mitchell Park Domes 69
10. Aerial Views of Downtown Milwaukee 75
11. Random Images of Milwaukee 85
12. Mayfair Mall's Ice Chalet 97
13. Milwaukee Signage 103
14. Capitol Court Shopping Center 111
15. 1950s Milwaukee County Stadium 119

About the Author 125

RAY SZOPIERAY COLLECTION

R aymond E. Szopieray was born on April 25, 1908, and graduated from Bay View High School in 1926. Ray documented the Milwaukee area from 1935 to 1985 with his Olympus Pen-F camera. When he wasn't photographing Milwaukee, he was working a day job at Pittsburgh Paint in the Chemistry Lab. In early 2016, Karl Bandow and this author discovered a treasure trove of old Kodachrome boxes of Ray's slides of the city while rummaging through the American Estates antique store in Bay View, Wisconsin. This collection of Ray's slides showcases downtown Milwaukee from the mid- to late 1970s.

According to the owner of American Estates, Leonard Budney, the boxes had been sitting around the store for a couple decades. After all that time sitting in the store, collecting dust, the images have meaning again. They offer a glimpse of the gorgeous colors of Milwaukee as it appeared in the '70s. The progression of the city is evident through the images, which capture views many Milwaukeeans never saw in person or may have forgotten. After Ray's death in 1992, his collection of over twenty-five thousand images documenting Milwaukee was donated to the Milwaukee County Historical Society in 2004. It is unknown how the slides ended up at American Estates, but we can all be glad they did. Although Ray is no longer with us, his photography lives on, opening a window to a Milwaukee that has since vanished.

The entire block of Third Street and Wisconsin Avenue was demolished sometime between the late '70s and early '80s, and the corner of Third

Street and Wisconsin Avenue was replaced with the Henry Reuss Federal Plaza. When the following photographs of downtown were taken, Grand Avenue Mall didn't exist, and Third Street went through Wisconsin Avenue and Michigan Street. Fourth Street and Wisconsin Avenue were swarming with people who were shopping and working downtown. In these images, one can see the Wisconsin Hotel in the background and, on the left though other buildings, the Century Building, which was home to Radio Doctors. Fifth Street and Wisconsin Avenue was home to the Strand Theater, Pizza by the Slice, City News and Schwartz Bookshop, formerly Clock Steak House and Piano Bar before it moved to the Iron Block building years later. Prior to the Voom Voom Room strip club, located on the northwest corner of Fifth Street and Wisconsin Avenue, the building was home to live music performances for many years. Miller High Life Spa opened in the early 1960s, which led to the opening of the Penthouse in the mid-1960s. The spa hosted mainly local and regional rock and country bands with a majority of older fans. It was also one of the first businesses with strippers in Milwaukee, and the city didn't want to give it a liquor license. After some debate, the city relented. The Voom Voom Room was the last establishment to occupy the building. By the mid-1960s, North Fifth Street was on the decline. Depending how you feel about adult bookstores and dive bars, Wisconsin Avenue became less classy than it once was, and there were many seedy elements in this part of downtown from the late 1960s through the 1970s. As a result, everything on North Fifth Street was ultimately erased. There was also a great deal of B-girl (women who entertained bar patrons and encouraged them to spend their money) activity. The block continued to decline into seediness, with prostitution busts becoming a frequent occurrence. According to a reliable source, when the Voom Voom Room closed, its signage was moved to its new location in Louisville, Kentucky. Looking east from the 500 west block of Wisconsin Avenue, a wider view of the street, as well as the Pabst building, can be seen in the distance. In 1975, construction began on the new Wisconsin Avenue Bridge over the Milwaukee River. In the background, the Pabst Building, which was demolished in 1981 and replaced in 1989 with the 100 East Wisconsin Avenue building, can be seen.

OPPOSITE, TOP Third Street and Wisconsin Avenue, 1979. *Ray Szopieray.*

OPPOSITE, BOTTOM Fourth Street and Wisconsin Avenue, 1979. *Ray Szopieray.*

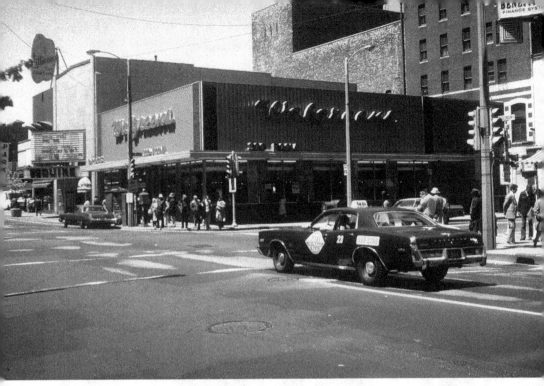

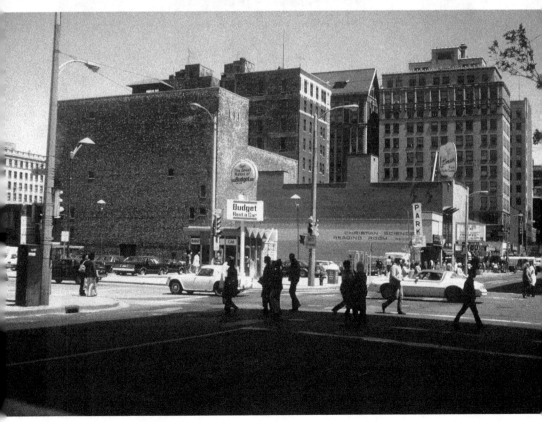

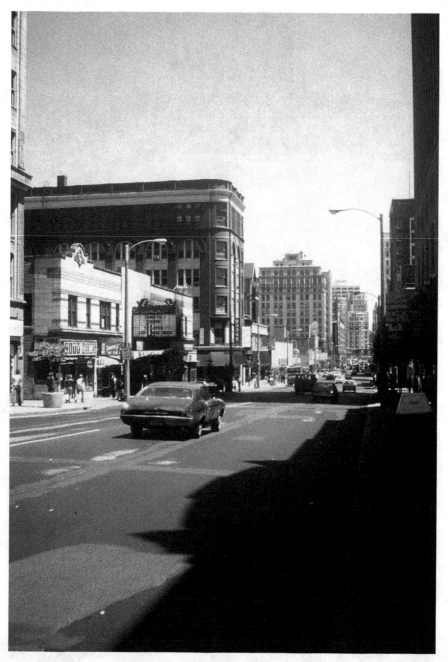

500 Block of West Wisconsin Avenue, 1979. *Ray Szopieray.*

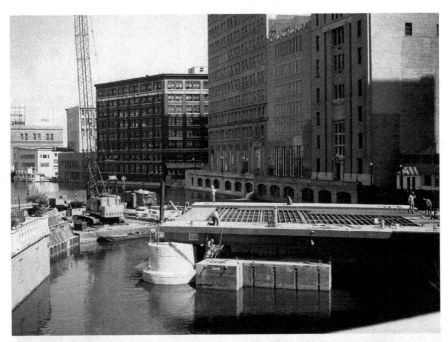

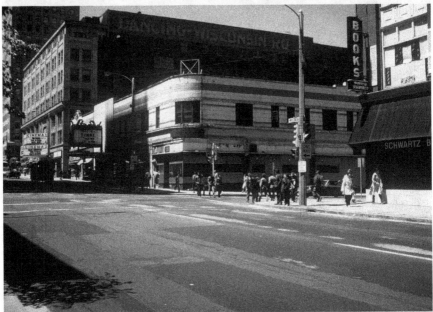

TOP Wisconsin Avenue Bridge, 1975. *Ray Szopieray.*

BOTTOM Fifth Street and Wisconsin Avenue, 1979. *Ray Szopieray.*

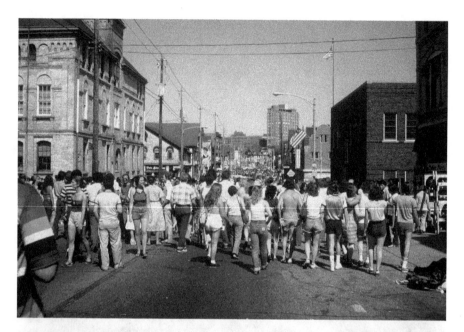

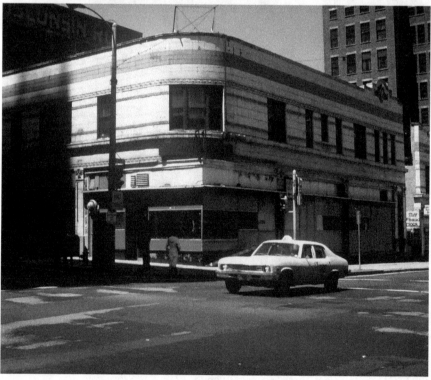

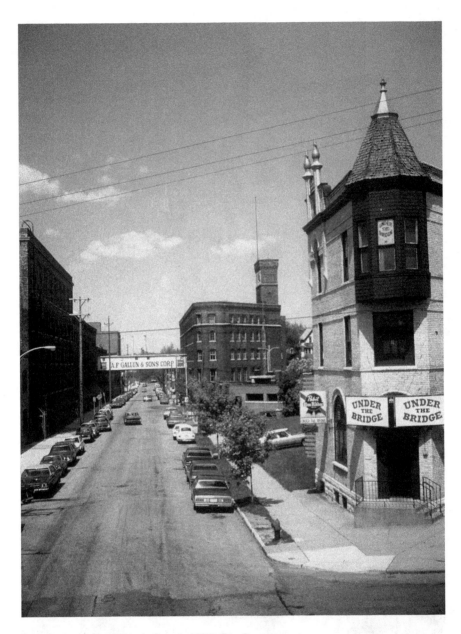

OPPOSITE, TOP Brady Street, 1979. *Ray Szopieray.*

OPPOSITE, BOTTOM The former Voom Voom Room. *Ray Szopieray.*

ABOVE North Water Street, 1975. *Ray Szopieray.*

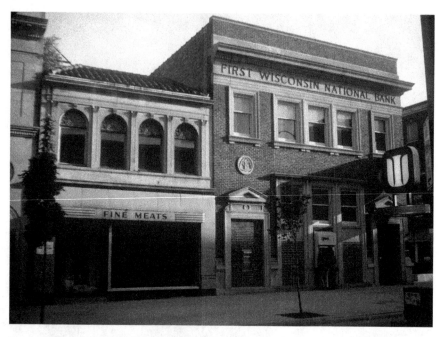

Tenth Street and Mitchell Street, 1975. *Ray Szopieray.*

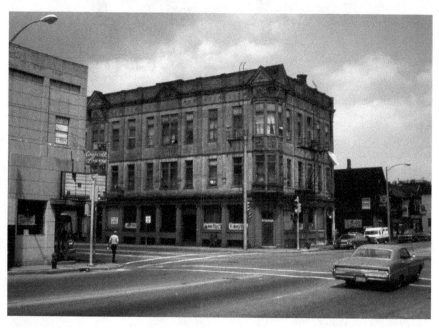

Telephone House at Second Street and National Avenue, 1975. *Ray Szopieray.*

Looking northwest on Fifth Street and Wisconsin Avenue, the Schwartz Bookstore, Voom Voom Room, Carpenter building and old Wisconsin Theater (opened in 1924), along with a sign for the rooftop ballroom, can be seen. The city demolished the theater in 1986 for new development.

On North Water Street, near the Holton Avenue Bridge, looking at "Under the Bridge." The bar was owned by John and Joe Eidenshink from 1976 to 1984. There was a long stretch of the Gallun Tannery buildings, seen on the left, which were razed for new development in 2011.

Tenth Street and Wisconsin Avenue was one of the city's busiest shopping streets. The First Wisconsin branch was located there, along with a TYME machine (Take Your Money Everywhere). TYME machines were quite common in southeastern Milwaukee and became an integral part of Milwaukeeans' lives. The cash machines were pioneered in the region as a way to get cash from a bank well before ATMs were popular. People in Milwaukee still tend to call ATMs TYME machines. If Milwaukeeans tell someone from another city that they are looking for a TYME machine, they may get a very puzzled look.

The Telephone House stood on Second and National Streets in Walkers Point circa 1979. The building was originally the German American Bank, founded in 1886. The building has housed many businesses over the years, including Walker's Point U.S. Post Office. On September 10, 1986, a five-alarm fire destroyed the building.

STATE FAIR PARK'S
MILWAUKEE MILE SPEEDWAY

any Milwaukeeans have fond memories of watching races at the West Allis Milwaukee Mile on the grounds of the Wisconsin State Fair. The track was originally a 1-mile private horse racing circuit in 1876. The Agricultural Society of the State of Wisconsin purchased the site in 1891 to create a permanent location for the Wisconsin State Fair. It held its first motorsport event on September 11, 1903. William Jones of Chicago won a five-lap speed contest and set the first track record with a seventy-two-second, 50-mile-per-hour lap. There were twenty-four-hour endurance races in 1907 and 1908, and Louis Disbrow won the first 100-mile event in 1915, averaging 62.5 miles per hour. Originally a dirt track, the West Allis Milwaukee Mile was paved in 1954. Currently, the 1-mile oval racetrack, grandstand and bleachers seat approximately thirty-seven thousand spectators. Included is a 1.8-mile infield road circuit. As the oldest operating motor speedway in the world, the Milwaukee Mile has hosted at least one auto race every year since 1903, with the exception of the World War II years. The track has held events by the AAA, USAC, NASCAR, CART/Champion Car World Series and Indy Car Series.

State Fair Park was purchased in the late 1800s, and a new half-mile horse racing track was constructed there. The annual county fair took place on the grounds, but no auto racing was staged until 1914. It was reported that the race was "nothing remarkable," and the time made was not especially good on account of the wind. One vehicle belonged to the Wells Manufacturing Company of Des Moines, and the other racecar belonged to Fred Tone of the

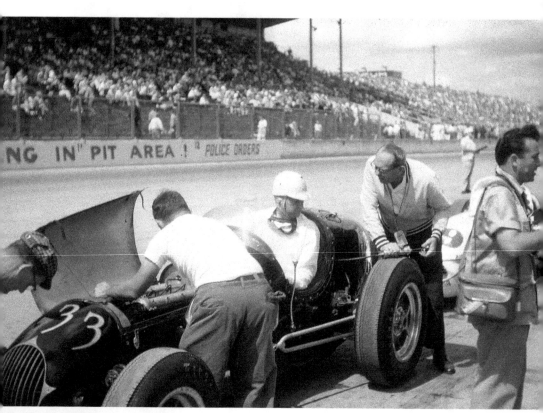

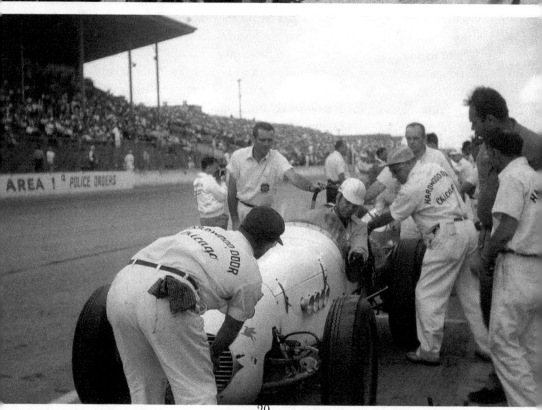

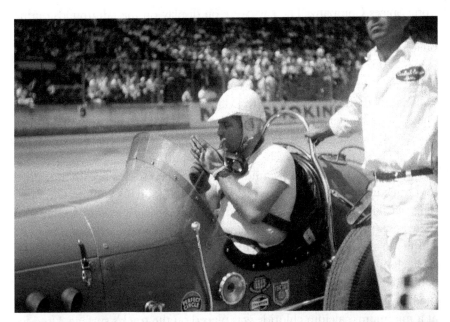

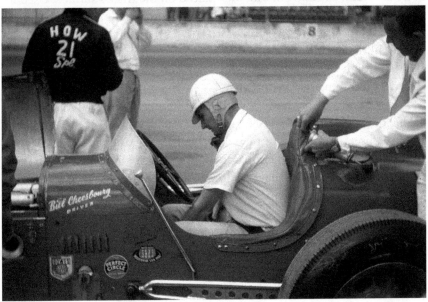

THIS PAGE AND OPPOSITE Milwaukee Mile, 1954–55. *Rudolph Rekokse.*

Tone Spices Company. The cars were on display on the fairgrounds during the day and drew sizeable crowds of onlookers. In 1917, all the fairgrounds' buildings were under construction (including the old, covered grandstand, which was razed in 1969). The track is located four miles from Harley-Davidson's headquarters on Juneau Avenue. It has a history of hosting AMA national races, dating to the 1920s. Many motorcycling legends, such as Jim Davis, Gene Walker, Joe Petrali, Floyd Emde and Bobby Hill, won on the track when it was still a dirt oval. When the track was paved over in the 1950s, the track's days of motorcycle racing came to an end.

Local high school football games and track meets took place on the infield and track until the late 1930s, when the current football stadium was built. This was also the time when automobile racing meets (as they were called then) took place on the track during the summer and early autumn. The success of these meets led to a string of racing events between 1927 and 1936. Johnny Gerber "Speed" Adams and other regionally known drivers competed in the meets during that time. Due to nonexistent lighting around the half-mile, all events took place during afternoon hours. To keep the dust at a minimum, calcium chloride was placed on the track's surface. Used for weekly events in the 1950s and 1960s, the one-mile and quarter-mile tracks were paved several times. In 1967, A.J. Foyt won the first USAC Stock Race at the Milwaukee Mile, and one year later, the track was repaved once again. By 1970, both the quarter-mile dirt track and half-mile road course were closed to accommodate the pit area.

Many famous racers have graced the Milwaukee Mile, including Barney Oldfield, Ralph DePalma, Walt Faulkner, Parnelli Jones, A.J. Foyt, Al Unser, Bobby Unser, Mario Andretti, Bobby Rahal, Jim Clark, Darrell Waltrip, Alan Kulwicki, Emerson Fittipaldi, Bobby Allison, Davey Allison, Nigel Mansell, Rick Mears, Michael Andretti, Alan Zanardi, Harry Grant, Rusty Wallace, Walker Evans, Dario Franchitti, Bernie Ecclestone and, last but not least, Paul Newman.

There was modified stock car racing in the area every night, with Monday races nearly always being at full capacity. The Milwaukee Mile also hosted modifiers and sportsman cars for many years, and it hosted

OPPOSITE Milwaukee Mile, 1958. *Unknown photographer, author collection.*

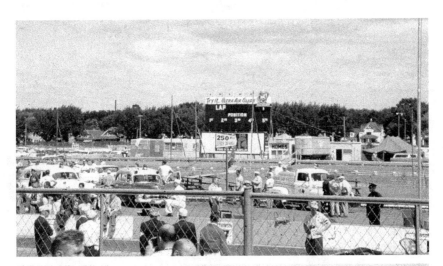

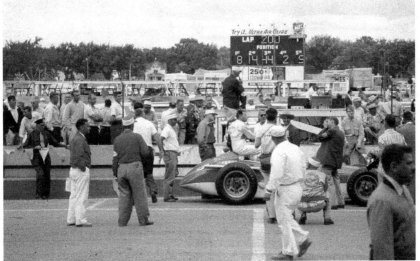

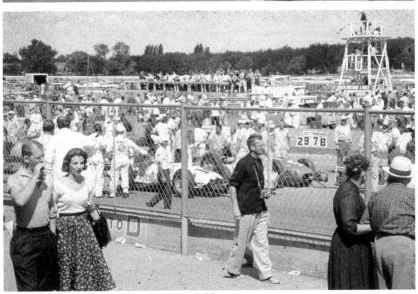

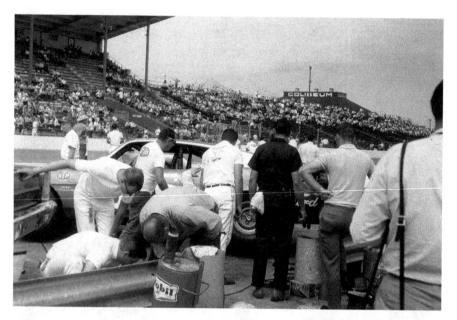

Milwaukee Mile, August 1969. *Unknown photographer, author collection.*

midget cars in the '40s and '50s. In the 1950s, there was a lack of safety devices for drivers—no roll bar, open cockpit, nothing to protect the driver from chunks of a shredded rear tire. It's no wonder drivers were killed with astonishing regularity. After many casualties, roll bars were mandated as well as cage protection.

It is also worth noting that from 1934 to 1953, the Green Bay Packers played several games a year on the Milwaukee Mile's infield. The mile also hosted the 1939 NFL Championship game. When the winds shook atop the grandstand, many reporters became concerned and left the game. The football games were moved to Green Bay, where there was a larger and safer stadium.

These Kodachrome slides span 1954 to 1955, with images that were taken during the AAA Stock Car Series. The collection then continues to 1958, with images that were taken during the USAC Stock Car Series, and then concludes in the late '60s, with images that were taken at the time of the USAC Champ Car Series and USAC Stock Car Series. These images bring us back to the glory days of the Milwaukee Mile. Look closely and you may hear the roaring sounds of the race cars as they speed around this magnificent track of yesteryear.

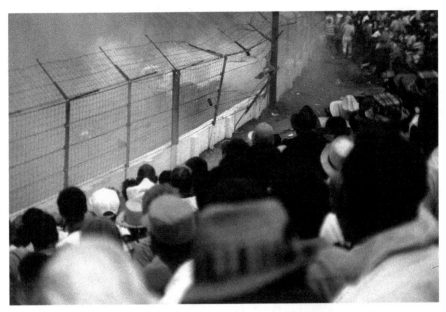

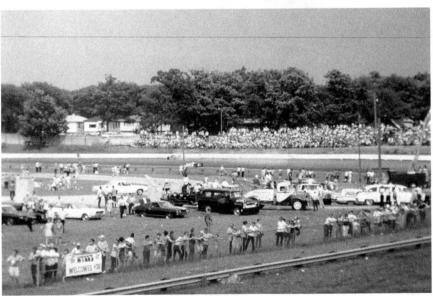

THIS PAGE Milwaukee Mile, June 1968. *Unknown photographer, author collection.*

3

LEGENDARY BRADY STREET

s a major thoroughfare through one of the city's most famous
neighborhoods, Brady Street has seen growth, change and
celebration for over 150 years. The nine-block stretch running east
to west through the east side exemplifies the ethnic diversity and festival
heritage of Milwaukee. Polish immigrants arrived on the east side of
Milwaukee on Brady Street in the 1860s. St. Hedwig Church's construction
was completed in 1871 on the corner of Brady Street and Humboldt Avenue.
They reconstructed the church into the building that is seen today in 1886.
Many residents in the area worked in nearby tanneries, factories and retail
shops along the street. The oldest surviving commercial building on Brady
Street is the Charles Sikorski building, which was constructed in 1875.
Today, it is the location of Brady Street Futons. My grandfather Edmund
Levin briefly owned a dry cleaning business in the same building. He sold
the business to a Carmello Sardina on October 31, 1950. Many Polish
immigrants eventually moved out of the area, and Italian immigrants moved
in. Brady Street was then referred to as "Little Italy." On February 14, 1946,
Glorioso's Italian Market opened and became a staple of Brady Street. It
is one of the unique grocery shopping experiences in Milwaukee, with the
aroma of fresh Italian sausages, breads and cookies wafting about. In 1948,
Peter Sciortino's Bakery opened. The bakery makes all of its products from
scratch daily to ensure the freshest baked goods. Both businesses continue to
thrive today. There is no other place like Brady Street in Milwaukee.

DRUGS

Schlitz

ANNUAL 1¢ Price Sale

DESERT FLOWER SO DRY

ANACIN
ANALGESIC TABLETS
FAST PAIN RELIEF
HEADACHE · NEURALGIA · NEURITIS

ANACIN
FAST PAIN RELIEF

MONEY ORDER

DRISTAN

DRISTAN

DI-GEL DI-GEL DI-GEL DI-GEL DI-GEL

Crest
fluoristan

IMPROVED
Crest
fluoristan

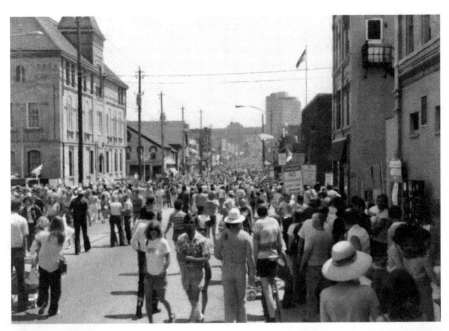

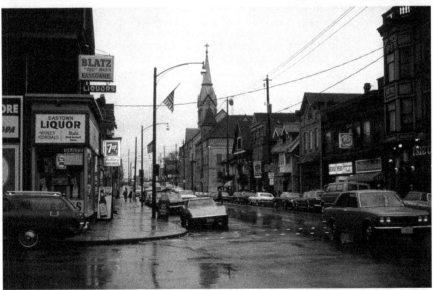

OPPOSITE Smith Drug Company on Brady Street in the early '70s. *Unknown photographer, author collection.*

THIS PAGE, TOP Brady Street Festival, looking east, 1973. *Jill-Koutroules-Bruss.*

THIS PAGE, BOTTOM East Brady Street and North Arlington Place, 1972. *Jill-Koutroules-Bruss.*

Milwaukee's hippie counterculture began to flourish during the 1960s, originating from antiwar movements that were smaller versions of the movement that was occurring in San Francisco's Haight-Ashbury District. The growth of the Brady Street Days Festival echoed the rise and fall of the area over the following years. There were a lot of record stores, head shops and handcraft shops up and down the street that catered to the new movement, and this was the foundation of the annual Brady Street Festival.

The festival was the brainchild of Bert Stitt in 1971. There was a lot of opposition to the festival in the beginning from the older neighborhood residents, but this didn't stop Bert, who went door to door with his clipboard and charmed them into letting it happen. Although the first festival was rained out in 1973, the following year saw approximately twenty thousand attendees. Eventually, many Milwaukeeans began to look forward to attending the festival and finding new ways to express themselves with newfound freedom. The great thing about these "do-it-yourself" festivals for vendors is they could just show up. There was no need for permits or any other sort of licensing. If a vendor made a little money, they were happy—if not, it didn't matter. The experience of the festival outweighed making a buck. The end of the festival was signified by the vendors joining the party. A usually quiet, quirky neighborhood was turned upside down so the rest of

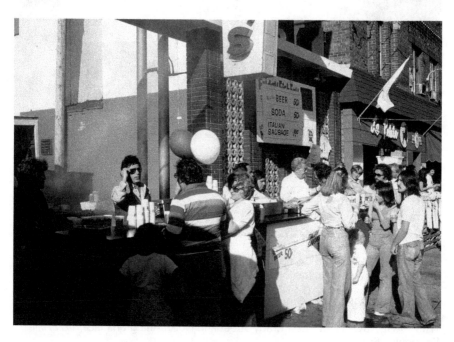

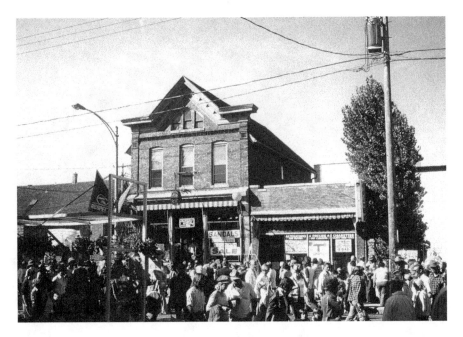

ABOVE AND OPPOSITE Brady Street Festival, 1979. *Ray Szopieray.*

the city could be a hippie for a day. Not everyone, however, enjoyed Brady Street Days. The side streets on Brady Street would get overcrowded with people who parked on lawns and in private driveways—not to mention the many drunk and otherwise intoxicated festivalgoers who caused havoc while others kept the peace, just sitting outside on strangers' porches.

While looking at this chapter's photographs, you can almost smell the patchouli oil. The slide taken in 1972 on the corner of East Brady Street and North Arlington Place, looking west, catches the eye with the signage it shows on both sides of the streets. When the photograph was shared with the Old Milwaukee group on Facebook, member Gerry Luisier noticed his father's Corvette parked on the corner. Just when someone thinks they've seen every photograph of their family, an image they never knew existed resurfaces.

MILWAUKEE'S GERMAN FEST

Gerrman Fest is one of many ethnic festivals celebrated on Milwaukee's Summerfest grounds, located along the shoreline of Lake Michigan. Established in August 1981 and considered one of the largest German festivals in North America, the fest celebrates German culture and traditions. It is held annually during the last weekend of July, and it attracts thousands who wish to sample its ethnic food, music, dancing, costumes and customs.

Although Milwaukee welcomed many immigrants, Germans quickly became the largest immigrant population in the city. By 1880, they comprised 27 percent of the city's population. Former mayor Henry Meier asked the various German groups to create a gathering similar to other ethnic festivals in Milwaukee.

At the festival, families continue to enjoy fireworks, parades, carousel rides, ethnic candies in the marktplatz (marketplace), a playground, the Battle of the Mascots, the Dachshund Derby, the Glockenspiel and costumed dance performances. Die Freistadt Alte Kameraden, an eighteen-piece brass and wind ensemble band that was formed in 1942, has been a staple at the fest for over forty years performing Blaskapelle music.

Another attraction at the fest is the card game Sheepshead. A popular American card game, it originated in central Europe during the eighteenth century. It is the American version of the German trick-taking card game Schafkopf. The card game quickly wove itself into the fabric of Milwaukee's

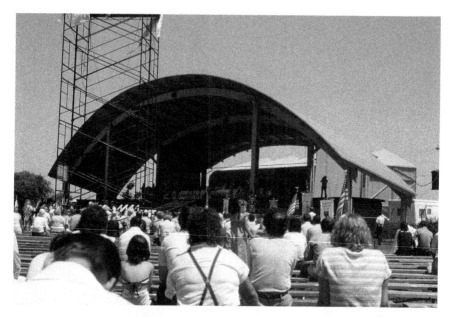

A crowd listening to Germanfest music at the old Rock Stage on the Summerfest grounds, 1980. *Unknown photographer, author collection.*

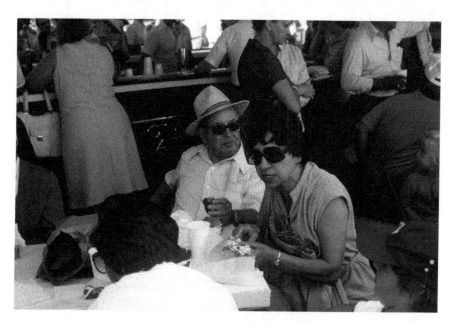

Husband and wife at Germanfest on the Summerfest grounds, 1980. *Unknown photographer, author collection.*

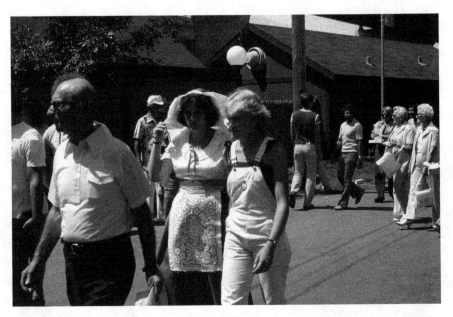

Crowds at Germanfest on the Summerfest grounds, 1980. *Unknown photographer, author collection.*

heritage, as German Americans played the card game competitively in their homes and neighborhood gathering spots. Numerous leagues of players gathered at taverns and beer gardens to play and enjoy a mug or stein of beer.

The beer stein also has a rich history in Milwaukee. Steins, made out of stoneware, glass or pewter, were originally created in Germany to combat health issues and improve the taste of the beer. The hinged-top lid prevented diseased flies from getting into one's drink. Owning a personalized, unique stein became a status symbol, and family collections have been proudly displayed since the thirteenth century.

The food at German Fest is as important as the beer. The following are ever present on the menu.

- bienenstich, a traditional German coffee cake filled with a special custard and topped with almonds and honey
- marinated Bismarck herring served on a bun
- frankfurter, hot dog
- goulash made with seasoned stew meat that is paprika-flavored and served on a bed of noodles

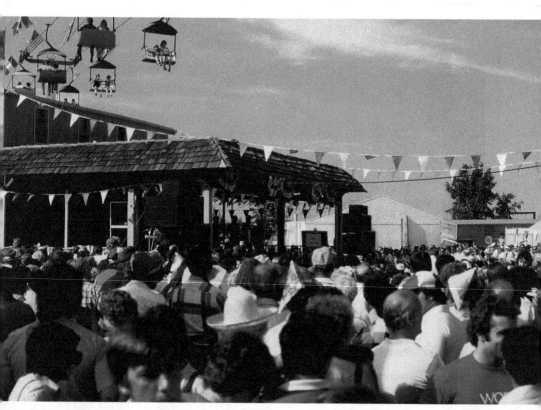

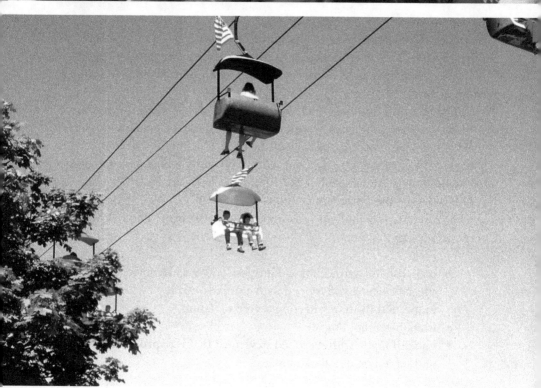

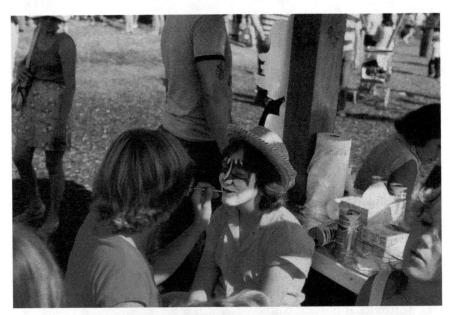

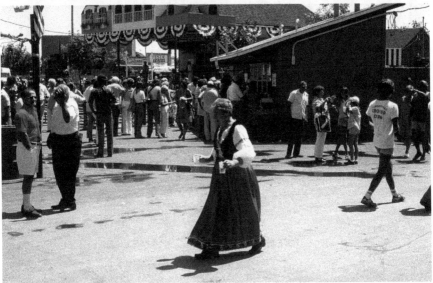

OPPOSITE, TOP Crowds listening to Germanfest music on the Summerfest grounds, 1980. *Unknown photographer, author collection.*

OPPOSITE, BOTTOM A sky glider at Germanfest on the Summerfest grounds, 1980. *Unknown photographer, author collection.*

THIS PAGE, TOP Face painting at Germanfest on the Summerfest grounds, 1980. *Unknown photographer, author collection.*

THIS PAGE, BOTTOM A woman with a beer in the crowd at Germanfest on the Summerfest grounds, 1980. *Unknown photographer, author collection.*

- brathering, or fried marinated herring
- kassler rippchen, smoked pork chops
- knodel, dumplings
- konditorei pastry/cake shop kuchen cake
- kartoffelpfannkuchen, pancakes made from shredded potatoes, served with sausage and applesauce
- rollbraten, roasted pork loin with sautéed seasoned onions
- rollmop, a piece of Bismarck herring wrapped around a pickle
- sauerbraten, marinated beef roast
- sauerkraut
- schnitzel, breaded boneless pork cutlet
- Schwarzwälder kirschtorte, Black Forest cherry cake
- spanferkel, roasted whole pig
- strudel, fruit-filled pastry
- torte, cake tart
- wurst, sausage
- authentic Bavarian soft pretzels

Milwaukee's German Fest tradition continues to draw international crowds because it is "All things German...for ALL ages."

MILWAUKEE BASEMENT PARTIES

Who can forget the immeasurable enjoyment of get-togethers in the rec room, rumpus room or game room? Every conceivable life event was celebrated in these spaces, which were centered on entertainment. The built-in bar, seating, games, food and music were essential elements, carefully selected by homeowners. Usually located in the basement, the room was typically larger than a living room and could serve multiple purposes while entertaining moderate-sized groups of all ages.

The pictures in this chapter portray the ambiance of the rec room, which depended on key elements: the bar setup (wet or dry), signage (beer signs, neon, glassware, beer stein collections, sports memorabilia or tiki hut–themed items), bar stools, refrigerators or coolers and a variety of beverages (hard liquor, cocktails, beer or soft drinks). Flooring ranged from brightly colored tile to sheet linoleum, and most rec rooms featured painted basement concrete block. Knotty pine paneling, however, was the "in" décor of the day—add to that comfy seating, bridge chairs and snack trays. To accommodate larger numbers, ping-pong tables and pool tables could masquerade as a dining table with the help of a tablecloth. Card clubs met regularly to play Sheepshead, poker, canasta, blackjack, gin rummy and penuchle. Other popular games of the time were ping-pong, darts, pool, foosball and air hockey. Music was provided by a record player, radio or, if one was fortunate, a jukebox. Depending on the music, dances included the jitter bug, twist, cha-cha, polka, slow dance, stroll and limbo. As seen in

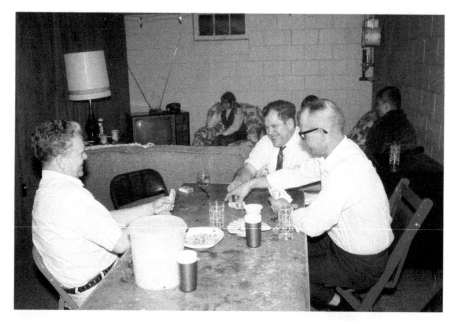

Poker at Bill Bruss's house, 1968. *Albert Lloyd Roberts.*

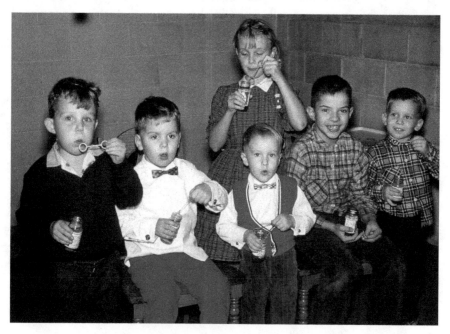

A basement party with kids, 1961. *Unknown photographer, author collection.*

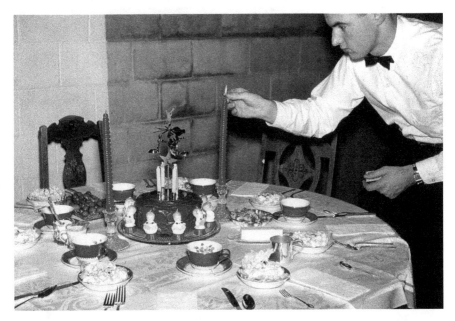

Lighting candles at a basement party, 1961. *Unknown photographer, author collection.*

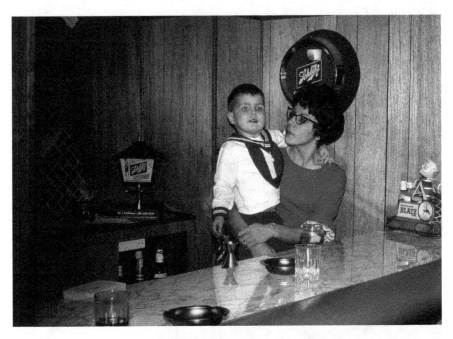

A mother and son behind a bar, 1967. *An estate sale find from Mark L. Leister.*

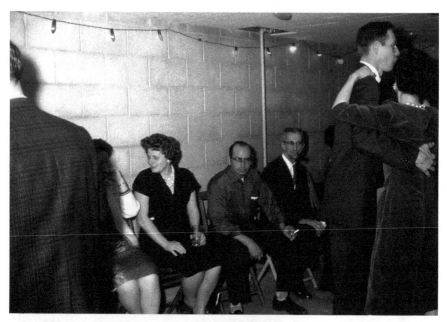

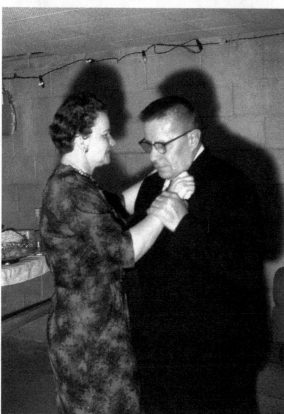

THIS PAGE A New Year's Eve party, December 1962. *Albert Lloyd Roberts*.

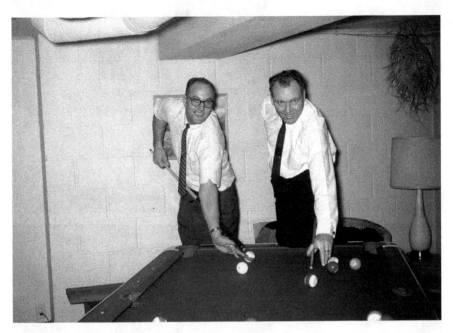

A pool table, February 1965. *Dorothy M. Bitters.*

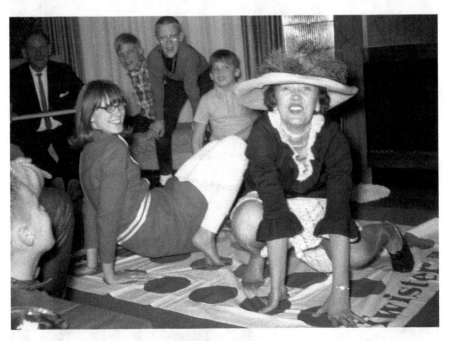

Twister, January 1967. *Dorothy M. Bitters.*

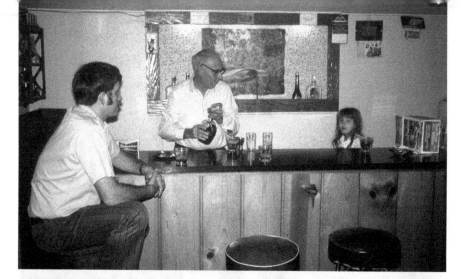

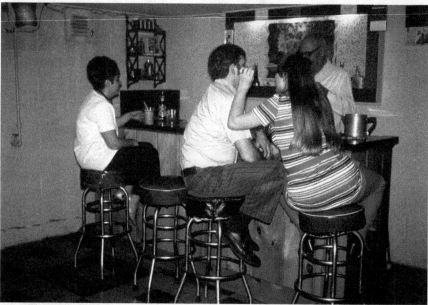

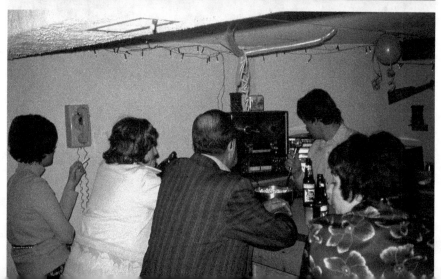

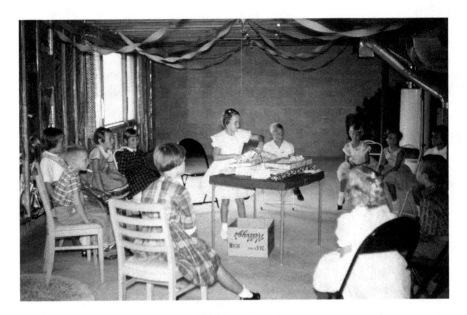

OPPOSITE A basement bar, 1970. *Ronald Strode.*

ABOVE A birthday party, year unknown. *Schwanke estate sale.*

this chapter's photographs, on special occasions, partygoers' clothing was more formal than casual. Men often wore suits or sport jackets. Women wore dresses or skirts and—for the hostess—organdy aprons. Appropriate dress for teen parties was expected as well.

Of all the rec room memories, special event dinners stand out. Although the requisite hams, turkeys and lasagnas were often featured, it was the side dishes, cocktails and desserts that were the most memorable. Jell-O molds in various shapes, colors and flavors were a centerpiece on every table. Swedish meatballs, tuna casserole topped with crushed potato chips, deviled eggs, celery filled with cream cheese, Cheez Whiz, pigs in a blanket, fondues for dipping, frosted chiffon and angel food cakes, pineapple upside-down cake and meringue-based pies like baked Alaska all made an appearance. Popular cocktails mixed at the bar included the highball, vodka martini, gin rickey, Singapore sling, gimlet, Tom Collins, Manhattan, old fashioned, sidecar, Seven and Seven and daiquiri. In addition to Coke and Pepsi, the soft drink brands available included Roxo, Graf's root beer and 50/50, Glen Rock, Royal Crown (RC) Hires, Diet-Rite, Fanta and Dr Pepper.

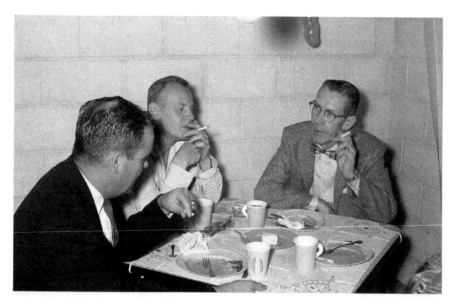

Men at a table in a basement, 1960. *Mark Winter.*

The photographs in this chapter echo with the sounds of laughter, chatter, music, card shuffling and ping-pong and pool balls clattering and the scent of beer, cigarettes and food favorites. All emanate from the basement rec room.

DOWNTOWN MILWAUKEE PARADES

The Great Circus Parade was founded by Charles "Chappie" Fox and Ben Barkin in 1963. Fox was a circus historian and philanthropist from Milwaukee who expanded Baraboo, Wisconsin's Circus World Museum. He believed staging a traditional circus parade would raise awareness for his Circus World Museum and also fund future circus wagon acquisitions and restorations. Barkin was a lifelong Milwaukee philanthropist and visionary. Dubbed "the best publicist in the country," he was fond of Fox's vision of re-creating an old-time Milwaukee circus parade featuring hundreds of restored nineteenth- and twentieth-century wooden circus wagons.

Both Fox and Barkin brought the idea to Robert Uihlein Jr., a chairman of Schlitz Brewing Co., convincing him to sponsor the parade from 1963 to 1973. Uihlein bought numerous cars for the museum, painting them in bright colors and adding individual show titles on each car. The 3.4-mile parade route was known for its pageantry and colorful wagons, brought by rail on flatcars from the Circus World Museum. Most of the transported wagons were obtained from the World of Mirth Carnival. The unloading and staging took place in Milwaukee's Historic Third Ward Rail Yard.

During this time, the parade attracted over one million attendees annually, second only to Pasadena's Rose Bowl Parade. It was a long-standing Fourth of July tradition to have circuses travel by rail to each city, attracting publicity with music, animals and ornamental wagons. Oscar-winning actor Ernest Borgnine played the "grand clown" for the parade's entirety. Known for his roles on the big and little screens, he became one of Milwaukee's favorite sons for these performances. Even though he wasn't originally from Milwaukee, he was elected an honorary clown from 1963 to 2009.

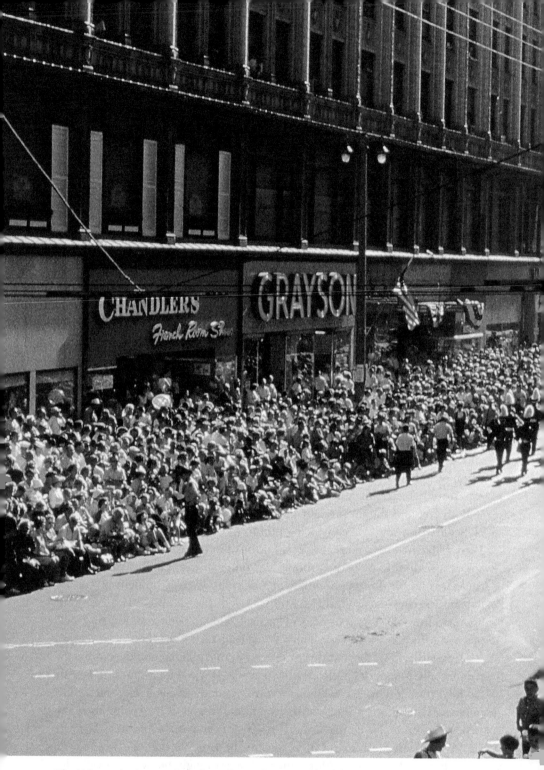

The Wisconsin Avenue Parade in the early '60s. *Unknown photographer, author collection.*

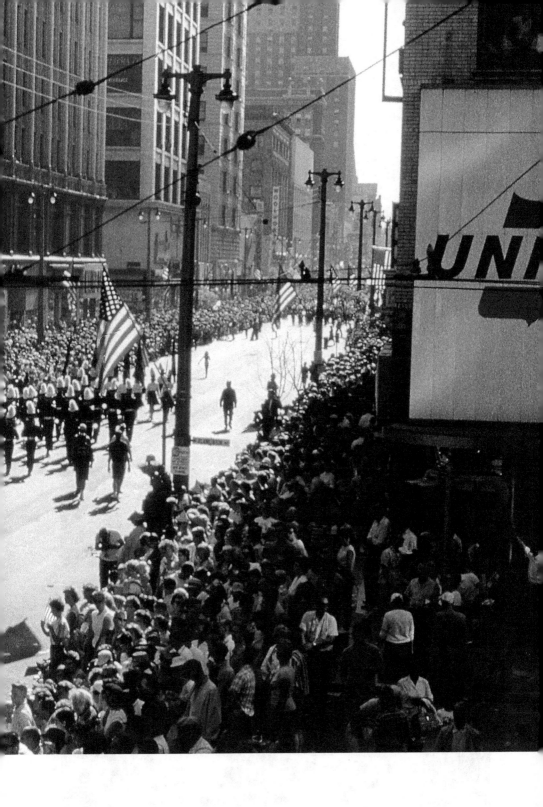

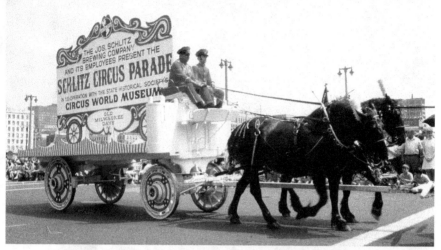

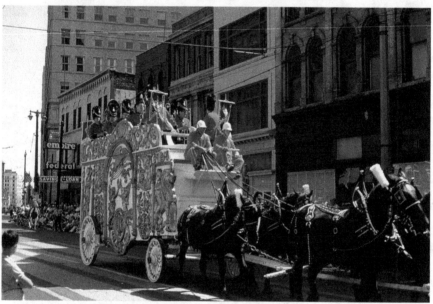

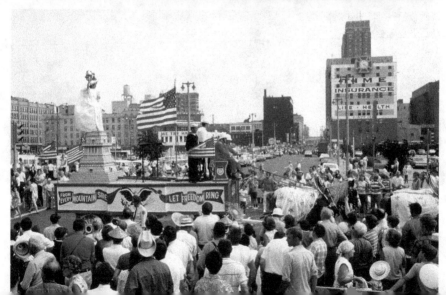

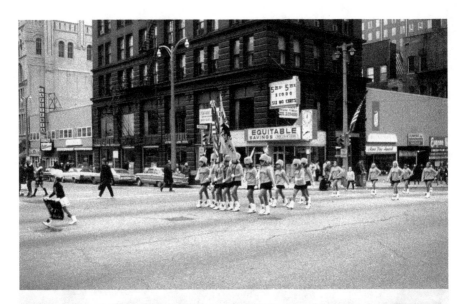

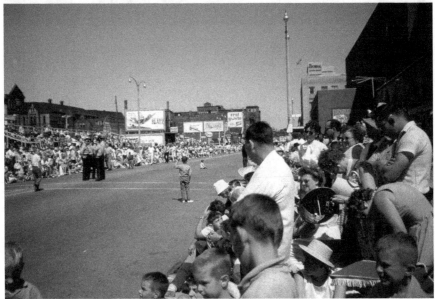

OPPOSITE A circus parade, 1969. *Albert Lloyd Roberts.*

THIS PAGE, TOP A circus parade, 1967. *Unknown photographer, author collection.*

THIS PAGE, BOTTOM A circus parade, July 1963. *Unknown photographer, author collection.*

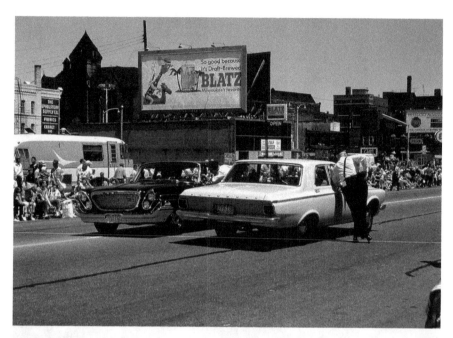

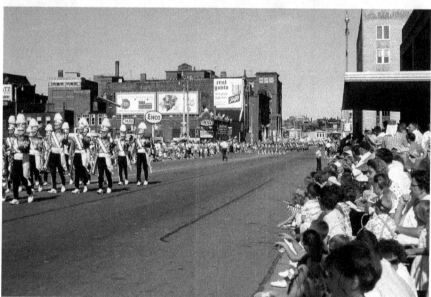

THIS PAGE AND OPPOSITE A circus parade, July 1964. *Unknown photographer, author collection.*

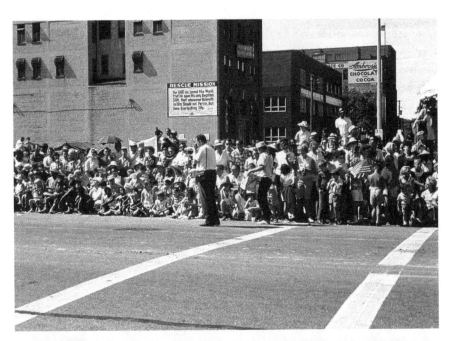

One additional attraction in the parade was Iowa farmer Elmer Sparrow's forty-horse hitch. This was the first time since 1904 that draft horses moved circuses through a town or city.

The annual parade helped fund and garner incredible publicity for the Circus World Museum. Proceeds saved countless circus wagons from demolition. The Great Circus Parade was held thirty times in Milwaukee and several times in Chicago and Baraboo. Barkin referred to the pageantry as "miles of smiles." The photographs in this chapter do not only record the era of Milwaukee's Great Circus Parade but also highlight Milwaukee's eclectic downtown architecture of the time.

SHRINERS CONVENTION
ON WISCONSIN AVENUE

This chapter's set of images is somewhat of a mystery. Little is known about the photographer, William Barrett, besides his name. Originally from New Orleans, Barrett took these photographs during a Shriners convention in Milwaukee on Wisconsin Avenue in September 1969. Showcasing what William saw while experiencing the sights and sounds of Wisconsin Avenue, the shots reveal a bustling downtown area full of shoppers and a patron entering the new Safe House, which had opened three years earlier. What amazes this author are the clarity and colors of these images—and the architecture on the avenue.

Although there was a parade for the Shriners, for whatever reason, there weren't any photographs documenting it. Barrett either didn't take them or separated them from the other slides. This chapter's candid images provide a fascinating glimpse of Wisconsin Avenue in 1969. The image of a Milwaukee Police traffic postman on his corner in the heart of downtown on Water Street and Wisconsin Avenue is especially charming.

For this 1969 convention, the Milwaukee Shriners hosted members from twenty-four Shriner temples in the Great Lakes area. Approximately ten thousand Shriners were in town. This was the largest number of Shriners Milwaukee ever hosted, which made for a busy weekend. The Shriners were easy to recognize in their red caps as they entered the MECCA Arena.

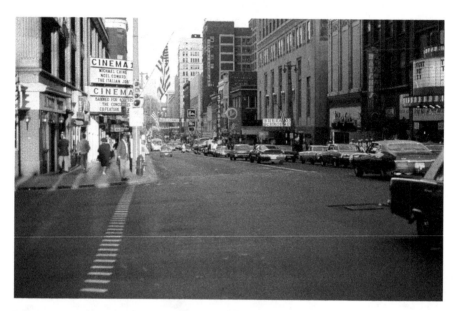

Wisconsin Avenue, looking east, 1969. *William Barrett.*

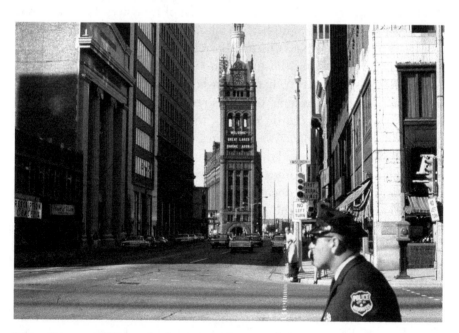

Water Street and Wisconsin Avenue, looking north on Water Street, 1969. *William Barrett.*

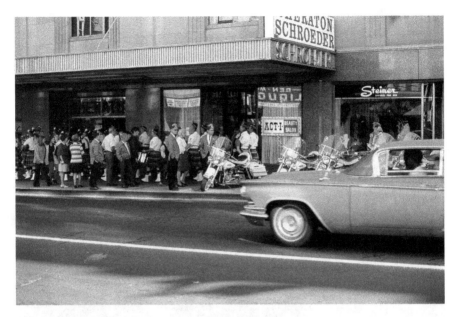

Wisconsin Avenue, looking south, 1969. *William Barrett.*

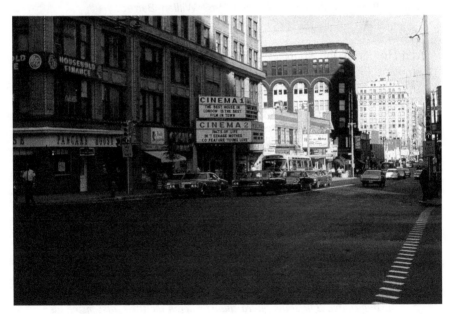

Wisconsin Avenue, looking northeast, 1969. *William Barrett.*

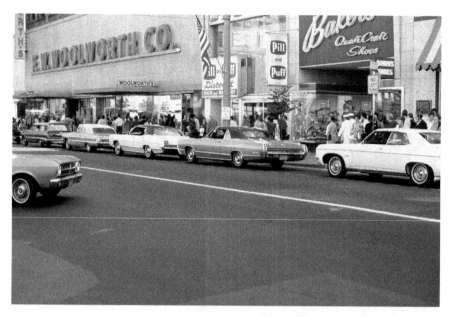

Looking southeast on Wisconsin Avenue, 1969. *William Barrett.*

Fred Holper of the *Milwaukee Sentinel* described the convention:

The fun caused ripples of laughter the length of Milwaukee's Main Street. Wedged between thousands of people three deep along the parade route, 10,000 Shriners of the Great Lakes Shrine Association marched or rode to sounds of laughter and applause that drew hotel patrons to their windows and the crowd to tiptoes. Some 8,000 people sat in the arena where the parade ended. Children who had been munching cotton candy and snow cones begged their parents to hoist them up so they could see better, their hands still sticky. Clowns, the expected part of any parade, did their usual thing and added to the anxiety of parents by dishing out candy and bubble gum to hundreds of waiting youngsters. Sailors from the Great Lakes naval training center in Milwaukee for the weekend stopped to watch the parade go by. One sailor got in on the fun and borrowed a pair of roller skates from a passing clown. The sailor glided clumsily down the street, dispensing the [bubble gum obtained from the clown], *pausing occasionally to help police direct traffic.*

The images in this chapter offer a glimpse of downtown Milwaukee during an era when shoppers still swarmed the streets from every stoplight. At the time, Cinema I and II at 530 West Wisconsin Avenue was the largest theater in Milwaukee. In the distance, Marc's Big Boy Restaurant on Fifth Street and Wisconsin Avenue made patrons want to slide into a booth and order a burger from a waitress named Mae, who called them "hon" or "dear." Also in the distance was Big Boy's Coffee Shop, where a strong cup of coffee and a slice of pie for $1.99 would set you right. The avenue was the place to go.

MILWAUKEE ARENA
(MILWAUKEE BUCKS)

This chapter's set of slides shows the Milwaukee Bucks playing the Los Angeles Lakers and Chicago Bulls at the Milwaukee Arena in the early 1970s.

In 1968, the Bucks entered the NBA as an expansion team and struggled through their first season, winning only twenty-seven games. But all it took to turn things around was a stroke of good luck in the spring of 1969. The fates of the Phoenix Suns and Milwaukee Bucks hinged on a coin flip to determine the number one pick in the 1969 NBA draft. The expansion Milwaukee Bucks gained the draft rights to one Lew Alcindor. Many predicted that he would transform the young Bucks into instant contenders. Averaging twenty-nine points a game and leading Milwaukee to a fifty-six-win season the following year, Alcindor did not disappoint. Legendary guard Oscar Robertson would join the team in a trade that sent expectations soaring.

The Bucks knew they were going to win the championship. The team's abilities at both ends of the court helped them ascend to greatness. With Robertson controlling the game from the perimeter and Alcindor unstoppable down low, the Bucks compiled a league-best 66–16 record and steamrolled their way to the championship round. In the NBA Finals, the Bucks swept the Washington Bullets. The Bucks had gone from an expansion team to NBA champions. No expansion team in any sport has ever won a championship faster than the Bucks, who captured the crown in their third year of existence.

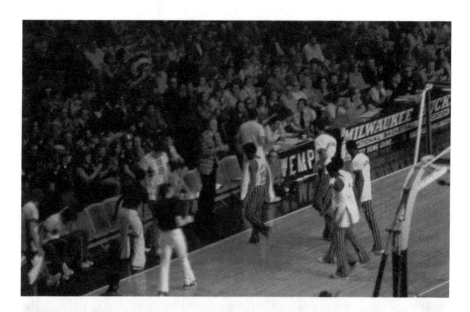

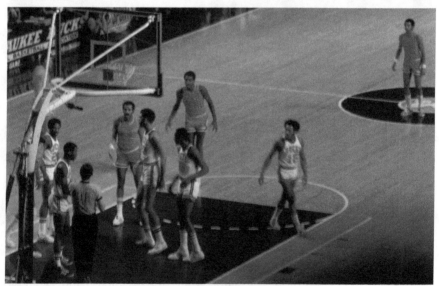

THIS PAGE, OPPOSITE AND FOLLOWING SPREAD The Chicago Bulls versus the Milwaukee Bucks at MECCA Arena, 1974. *Sheldon Berson.*

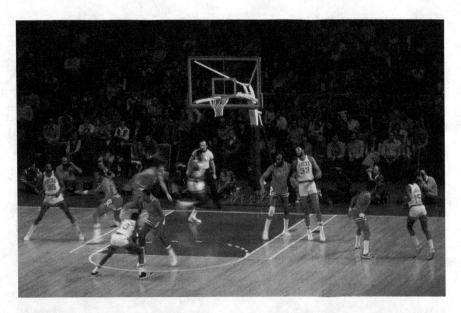

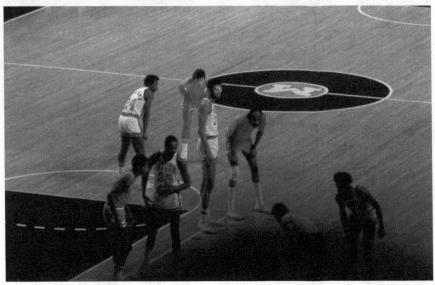

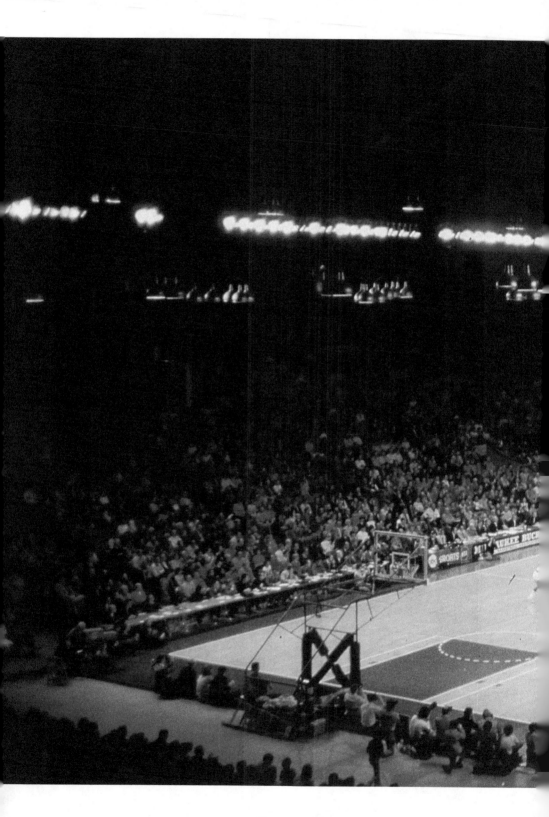

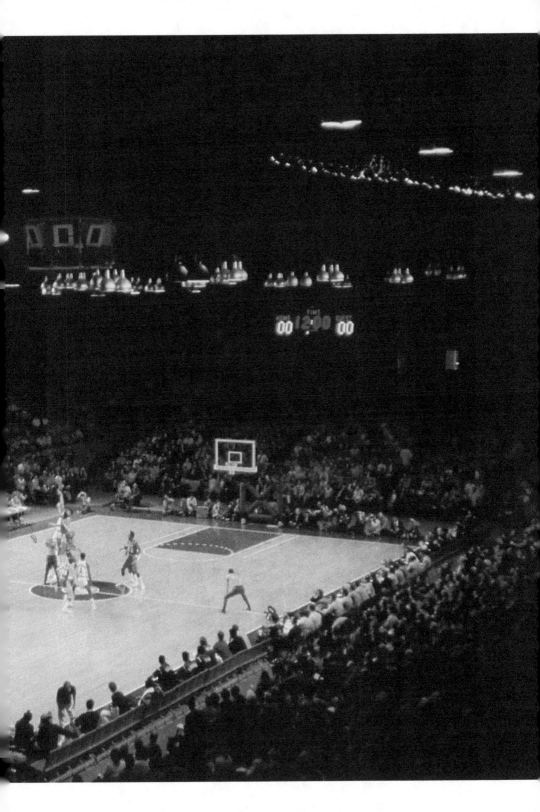

THIS PAGE AND OPPOSITE The Los Angeles Lakers versus the Milwaukee Bucks at Milwaukee Arena, January 9, 1972. *Sheldon Berson.*

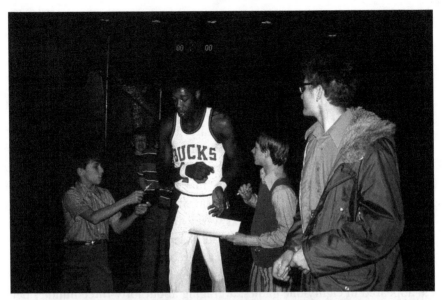

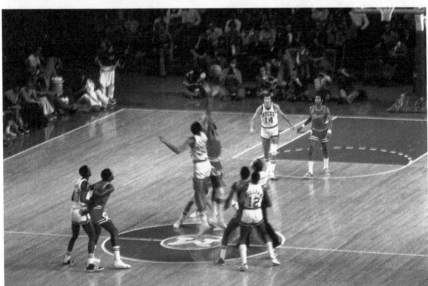

In 1974, the Bucks celebrated another championship. Overcoming a tough schedule to finish as the Midwest Division champions, they posted a 59–23 regular season record, once again best in the NBA. One more win would have given them their fourth consecutive season with 60 or more victories. Offensively, the Bucks carried the NBA's best field goal percentage mark, hitting 49 percent from the floor. Both Alcindor—now Kareem Abdul-Jabbar—and Bob Dandridge finished the season among the league's top ten percentage shooters. The Bucks achieved all this despite injuries. Most crucial was Lucius Allen's torn knee ligament two months before the NBA Finals and his subsequent surgery that put him on the injured list for the rest of the season and through the playoffs. Coach Costello was missing a starter in 20 games, and the Bucks were without at least one member of their roster because of illness or injury in 37 games.

Abdul-Jabbar led the club in scoring and rebounding; he was also among the league's leaders in scoring, shooting, rebounding and blocking shots. He appeared in eighty-one games, averaging about forty-three minutes per contest and setting an NBA record by averaging 6.4 assists per game. There was no question that this man was the king of the NBA. Unfortunately, a title wasn't meant to be for the Bucks. The Boston Celtics defeated them to win the NBA Championship.

MITCHELL PARK DOMES

A Milwaukee horticultural destination, the Mitchell Park Conservatory, also known as the Domes, is a group of buildings that were built in stages from 1959 to 1967. Lady Bird Johnson, the wife of President Lyndon B. Johnson, was in attendance at the dedication of the Domes in the fall of 1965.

The Domes were designed by architect Donald Greib in 1955. Each modern beehive-shaped dome spans a diameter of 140 feet and stands 85 feet tall, altogether covering 45,000 square feet. The Domes could be labeled as geodesic, but they are actually conical. They were designed this way to allow for more interior height for trees and better solar heating. The roof structures get their strength from the use of triangles to carry the load to the base. There are 2,200 triangular panes of glass in each dome, and each base must support the dead load of the structure and any loads presented during high winds and Wisconsin winters. A fan system at the base and top of each dome exchanges 750,000 cubic feet of air in three and a half minutes.

Every dome contains a unique physical environment or "biome"—tropical, desert or floral—and a regulated temperature. The first dome to open was the Floral Show Dome, which is representative of the Midwest's climate and features model train setups that run through the gardens. Its floral displays are changed five times a year. The Tropical Dome was opened in 1966 and features nearly one thousand species of plants, including fruit-

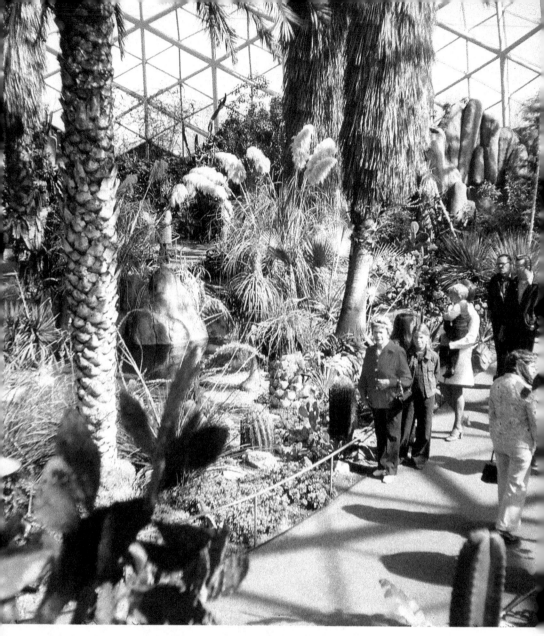

Mitchell Park Domes, April 1976. *Arthur Behling.*

bearing plants, like banana, papaya, ackee, guava and avocado trees. This dome is seasonally decorated with a variety of blooming plants, including a number of award-winning orchids. Many species of birds live inside the Tropical Dome as well. The Desert Aero Dome was the last to open in 1967. In 2013, six propagation greenhouses were constructed, and a seventh is utilized as space for weddings and special events.

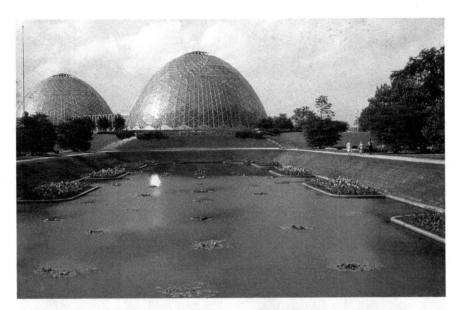

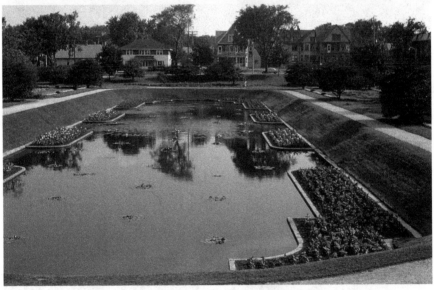

THIS PAGE AND NEXT Mitchell Park Domes in the mid-1960s. *David Kushnier.*

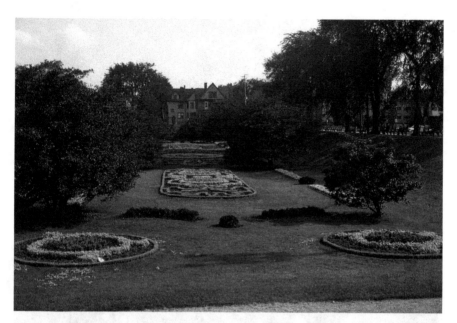

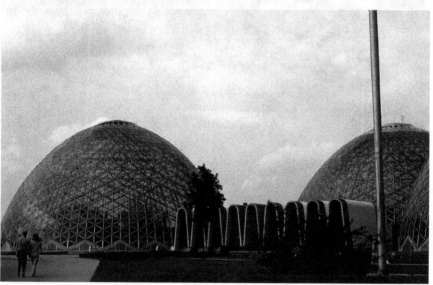

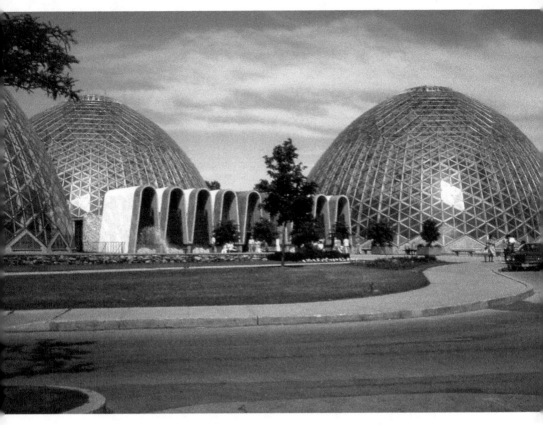

Mitchell Park Domes, 1979. *Ray Szopieray.*

In recent years, the Mitchell Park Domes have been under a tremendous amount of pressure to rebuild. Several costly repairs threatened a shutdown. In 2016, the Domes closed for three months for necessary structural repairs. Future improvements will be focused on more up-to-date environmental maintenance technology. This continuous environmental/structural attention allows the Domes to remain an important part of Milwaukee's legacy and a major year-round destination.

10

AERIAL VIEWS OF
DOWNTOWN MILWAUKEE

A s mass migration to the United States accelerated in the nineteenth century, numerous settlements re-created immigrants' home countries. Milwaukee is no exception; in the 1800s, it became as much a European colony as it was an American city. By far, the immigrants who most influenced Milwaukee were Germans, with hundreds of thousands arriving in Wisconsin in the nineteenth century. Many stayed at the most common point of entry into the state, the Port of Milwaukee. The images in this chapter display remnants of this German imprint in Milwaukee.

Through language, architecture and many other avenues, the Germans who stayed in Milwaukee after coming to Wisconsin transformed parts of the city into a remarkable facsimile of their home country. This chapter's aerial views of downtown reveal how Milwaukee almost looked like some cities along the Rhine. For example, Milwaukee's bold castle motif architecture and theaters resemble German opera houses. There is an acropolis in city hall, designed in the Renaissance Revival style with a direct influence from Hamburg City Hall. There are also many beautiful churches in the city that were built by the early German communities, and like most old churches, they offer a glimpse into historical European culture and architecture. During World War I, German culture came under fire, and Milwaukee felt a lot more like a typical U.S. city. However, the huge historic German presence in Milwaukee is still visible. Seeing all this, one does not have to wonder how the city once earned its nickname the "German Athens."

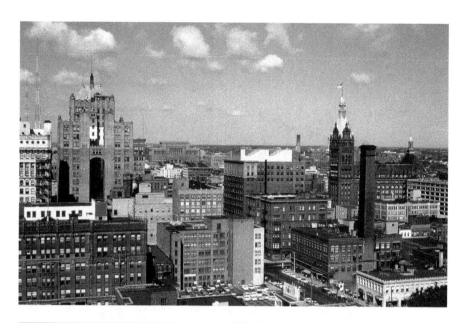

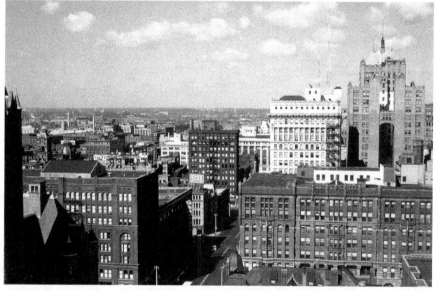

THIS PAGE Downtown, looking northwest, 1957. *Ethyl Smith.*

OPPOSITE, TOP Downtown, looking northeast, 1959. *Unknown photographer, author collection.*

OPPOSITE, MIDDLE Downtown, looking north at Milwaukee Courthouse, 1959. *Unknown photographer, author collection.*

OPPOSITE, BOTTOM Downtown, looking east at Wisconsin Tower, 1959. *Unknown photographer, author collection.*

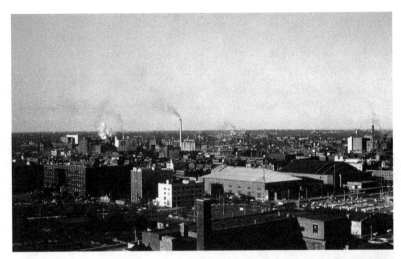

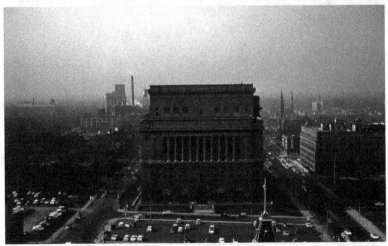

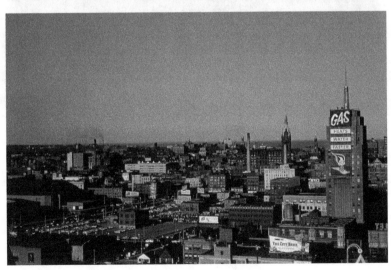

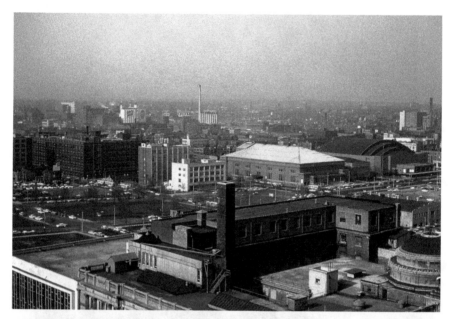

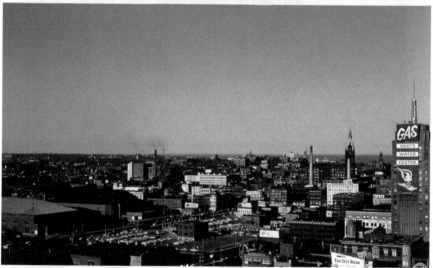

THIS PAGE, TOP Downtown, looking northeast, 1959. *Unknown photographer, author collection.*

THIS PAGE, BOTTOM Downtown, looking east, 1959. *Unknown photographer, author collection.*

OPPOSITE, TOP Downtown, looking northwest, 1964. *Glenn R. Reinders.*

OPPOSITE, BOTTOM Downtown, looking west, 1964. *Glenn R. Reinders.*

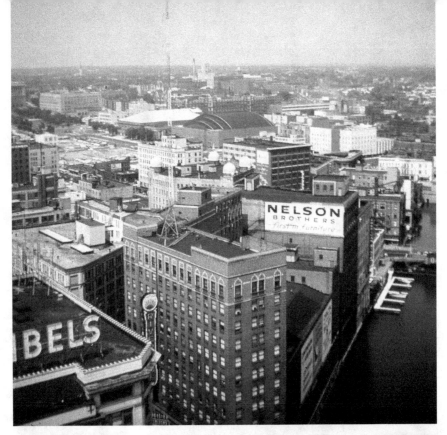

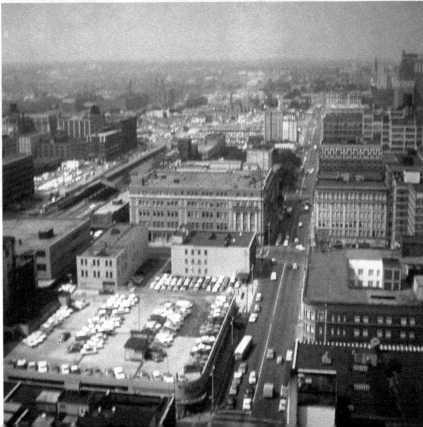

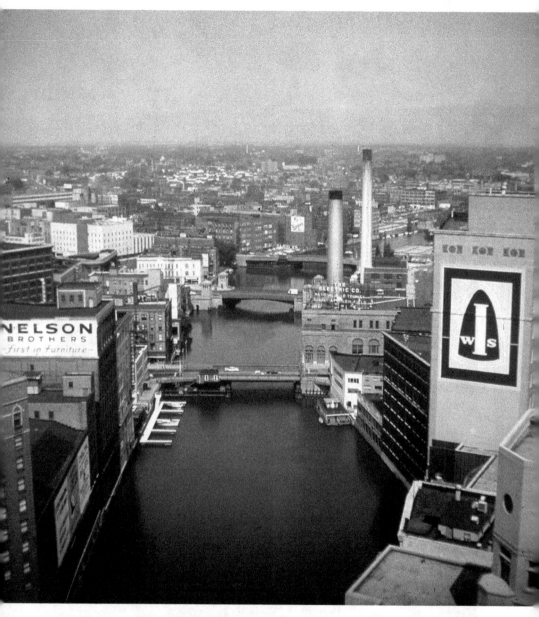

ABOVE Downtown, looking north, 1964. *Glenn R. Reinders.*

OPPOSITE, TOP Downtown, looking east, 1964. *Glenn R. Reinders.*

OPPOSITE, BOTTOM Juneau Town, looking north, 1979. *Ray Szopieray.*

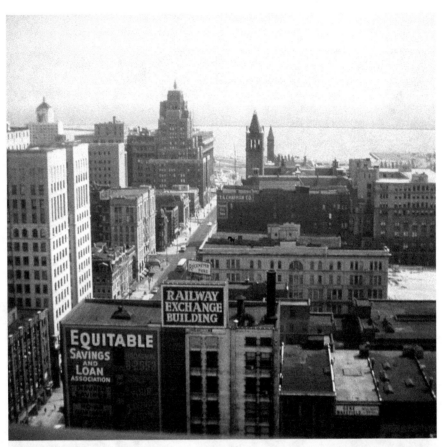

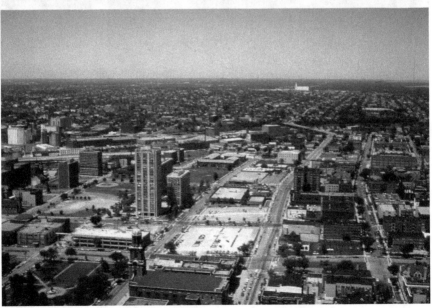

81

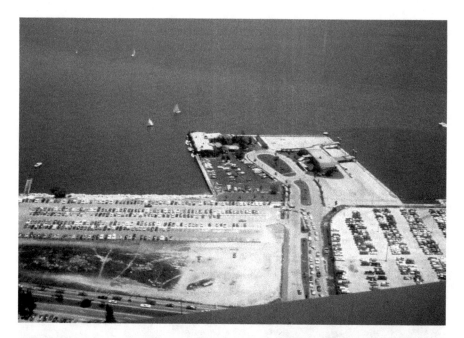

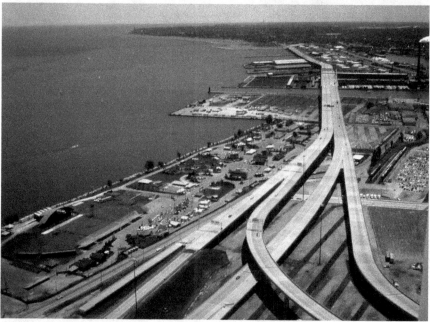

THIS PAGE AND OPPOSITE Looking east from the First Wisconsin building, 1979. *Ray Szopieray.*

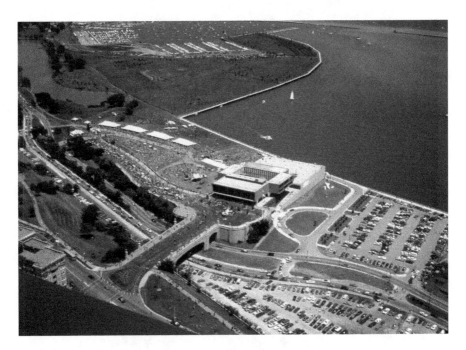

This chapter's aerial photographs are perfect illustrations of the industrial juggernaut Milwaukee once was. Schlitz Brewing was running at full speed, judging by all the steam coming out of its chimneys, a good indication of its level of production and availability of jobs. A lot has changed in downtown Milwaukee, but thankfully, a lot of its historic core has been preserved.

RANDOM IMAGES OF MILWAUKEE

T he following images do not share a theme, era or location, but they do share an inimitable charm.

The photograph of the Standard Oil Gas Station on Fifty-Ninth Street and North Avenue was taken in 1949. Evidently, the station attendant flipping the dials and change machine on his belt fascinated many customers. Across the street, Sport Bowl was a popular bowling alley.

Since 1950, Bay View's South Shore Frolics treated residents to parades, live music, classic car shows, fireworks and Pabst Blue Ribbon. This event took place over the course of one weekend every July until the tradition ended in 2017.

The image of a father and son shows part of the home located at 2916 South Ninety-Ninth Street. The parking lot of Norbie Baker's Pleasant Valley Inn was adjacent to the home and touched its backyard. Most of the homes in this neighborhood are three-bedroom ranches. The simplicity of the photograph captures the era and neighborhood perfectly.

The Boulevard Inn was a long-standing upscale restaurant on Sherman Boulevard and Lisbon Avenue. It was an ideal place for people to go on a first date and for weddings and birthdays. This chapter's image of the inn was taken by Albert Lloyd Roberts in 1968, a time when people could sit down at the bar, order a drink and light up a cigarette. The building was set ablaze due to arson in 1993 and was later razed to make way for the Milwaukee Public Library (Washington Park Branch). The restaurant was relocated to the Cudahy Tower building in downtown Milwaukee, which permanently closed in 2003.

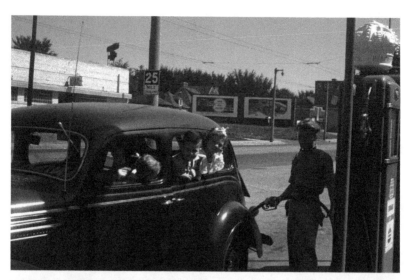

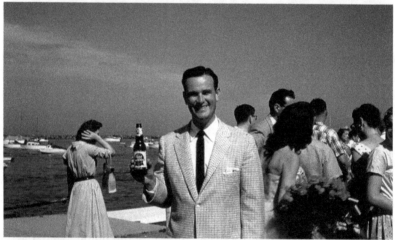

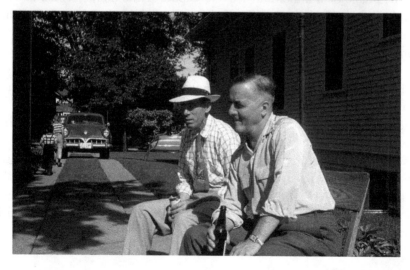

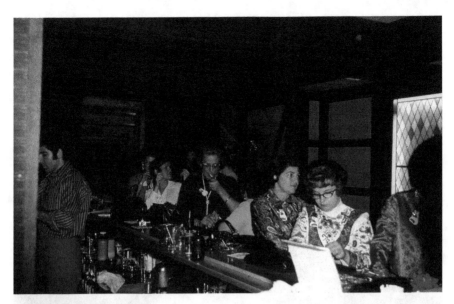

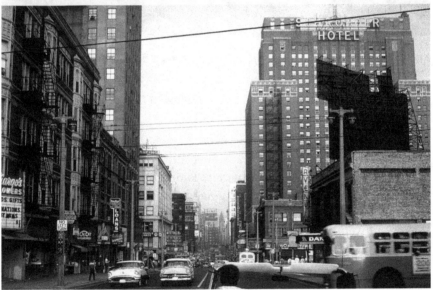

OPPOSITE, TOP Fifty-Ninth Street and North Avenue, 1949. *Harold Haas.*

OPPOSITE, MIDDLE South Shore Frolics, 1957. *Ethyl Smith.*

OPPOSITE, BOTTOM 2269 North Fifty-Ninth Street, 1952. *Harold Haas.*

THIS PAGE, TOP Boulevard Inn at Sherman Boulevard and Lisbon Avenue, 1968. *Albert Lloyd Roberts.*

THIS PAGE, BOTTOM Downtown Milwaukee, looking east on Wisconsin Avenue, 1961. *Unknown photographer, author collection.*

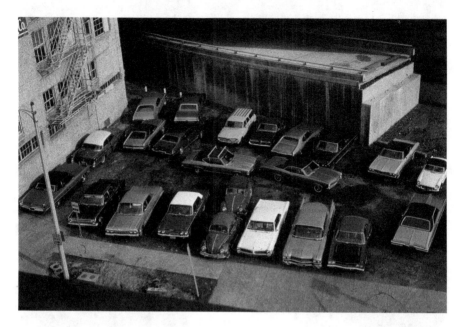

ABOVE A parking lot under the freeway at Saint Paul Avenue and Milwaukee Street, 1970. *Harold Haas.*

OPPOSITE Walker's Maple Grove at South Thirteenth Street, 1966. *David Kushnier.*

Looking east, Wisconsin Avenue was alive and well in 1961. Going shopping downtown was a frequent event for many Milwaukeeans, starting at Boston Store and Gimbels and then going to lunch with friends, Smartwear, Chapman's and Lou Fritzels or a movie in one of the majestic theaters on Wisconsin Avenue.

One of this chapter's images simply shows a parking lot next to an unfinished I-794 ramp near the intersection of St. Paul and Milwaukee Streets. The vintage vehicles appear like matchbox cars from where photographer Harold Haas took the photograph.

After a wedding in October 1966, David Kushnier took photographs at Walker's Maple Grove on South Thirteenth Street. Walker's was the place where family and friends went after a funeral or baby shower. The restaurant's Polish sausage, raw beef and onions was a popular choice on the menu. There are many captivating details in the images—from someone putting their cake on the top of their glass to the classic ashtrays and faces some of the people are making.

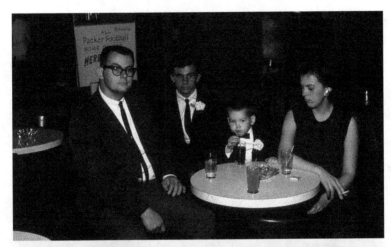

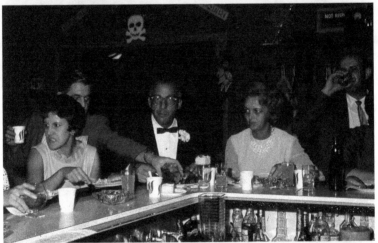

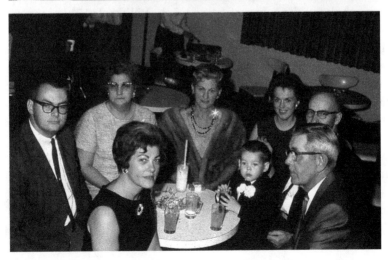

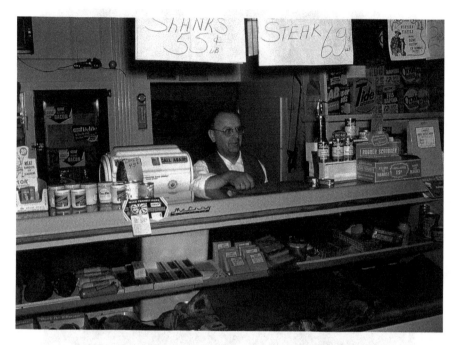

ABOVE Bill Stock behind the counter at Stock Foods on Keefe Avenue in the late '50s. *David Kushnier.*

OPPOSITE Chicago and North Western Railway Lake Front Depot, July 1963. *Dorothy M. Bitters.*

The next Kushnier photograph was a challenge to figure out. A member of the Old Milwaukee group on Facebook was able to find more details. The photograph shows the owner of Stock Foods, Bill Stock, behind the counter of his store on Keefe Avenue.

The Chicago and North Western Railway (C&NW) Lake Front Depot was a destination for many who were going in and out of Milwaukee. Taken by Dorothy M. Bitters, this image shows a grandmother and grandson posing in front of the trains in July 1963; one can also see the war memorial peaking out from a distance. The passenger station was located where O'Donnell Park is now, and the former railroad is now the Oak Leaf Trail. After 1965, C&NW's trains shared what is now the current Amtrak depot on St. Paul Avenue with Milwaukee Road, and the lakefront depot was torn down a few years later.

An image from 1966 shows a family gathering that was typical of the era—formal dresses for an informal get-together, with men in suits and ties

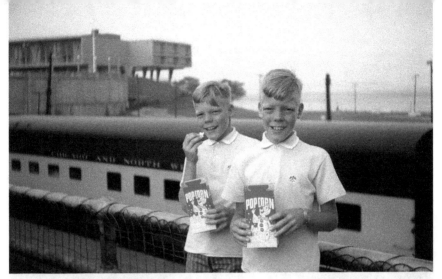

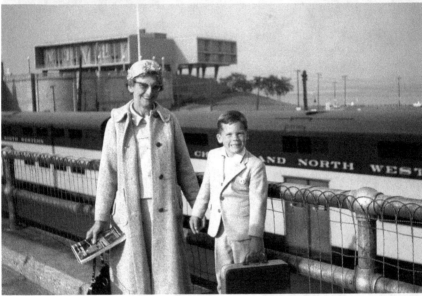

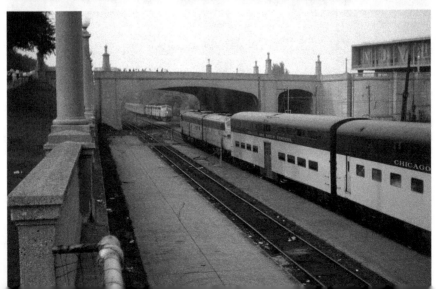

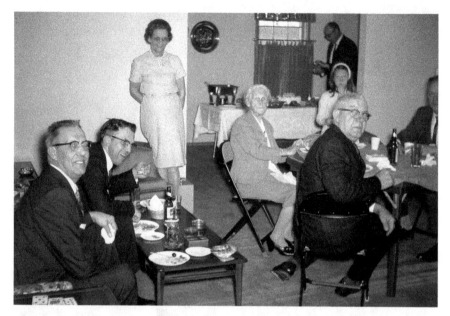

A family gathering in July 1966. *Dorothy M. Bitters.*

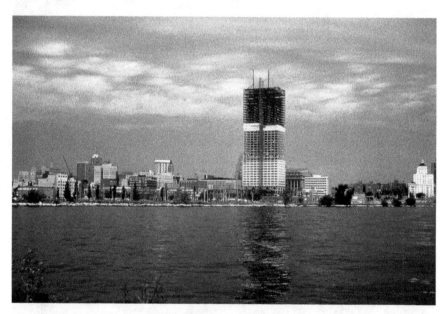

The construction of the First Wisconsin building, 1972. *John Aschon.*

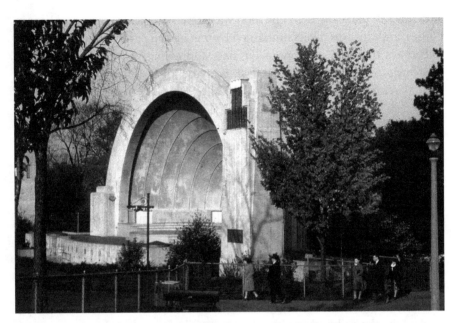

The Blatz Temple of Music in Washington Park in the 1950s. *Harol Haas.*

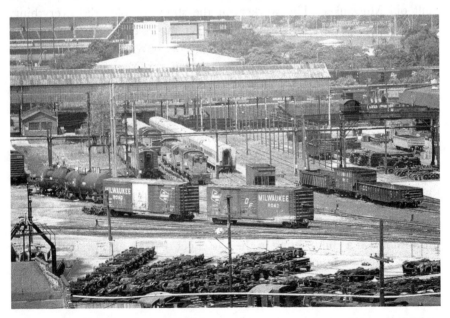

A Milwaukee Road railroad facility on June 1, 1976. *Unknown photographer, author collection.*

and ladies in party dresses. The food was served on paper plates and beer in bottles, and this was all accompanied by one or two card games.

Perhaps the most prestigious business address in Milwaukee is 777 East Wisconsin Avenue, home of the U.S. Bank building, formerly known as the First Wisconsin Center. Opened in 1973, it has been the tallest building in Wisconsin since that time. This image shows parts of Milwaukee's skyline, which was just forming in the early 1970s.

On August 23, 1938, the Blatz Temple of Music was dedicated at Washington Park. A crowd of over forty thousand people attended to hear Jessica Dragonette sing with the Wisconsin Symphony Orchestra. Emil Blatz, the son of brewery owner Val Blatz, donated $100,000 to build the band shell. At the dedication, Blatz said, "If this temple of music gives you as much pleasure as it has given me in donating it, I am fully repaid."

Milwaukee Road Railroad's home was located on many acres in the Menomonee Valley along the Menomonee River near stockyards and rendering, shipping and other heavy industry plants. Large groups of buildings are scattered throughout the area, and over five thousand people worked for the railroad, making boxcars, railroad cars and locomotives. A huge part of Milwaukee's history, the railroad facilities provided jobs that built old Milwaukee. The workers at the shop complex did everything, including constructing freight and passenger cars. The area was a bustling location that fueled the railroad with railcars for many decades. The railroad was founded in 1847 and during its time in the Menomonee Valley, it bought out numerous other railroads and had over eleven thousand miles of track from the west coast near Seattle to Indiana and southern Illinois. The locomotives were both electric- and diesel-powered, because when they reached tracks in Montana, the railroads switched from diesel power to electric power. Many people worked hard to contribute to the railroad's growth, building locomotive cars, laying and maintaining tracks and driving the locomotives. Railroad tracks radiated from the valley, and its buildings were large enough to service locomotives. This author misses the sight of cars rolling throughout the valley and the aroma of Red Star yeast. When the author was a child, sitting in the passenger seat, he always tried to get a good look at the Menomonee Valley from I-94.

OPPOSITE A German submarine, *U-505*, in the Milwaukee River, 1958. *Unknown photographer, author collection.*

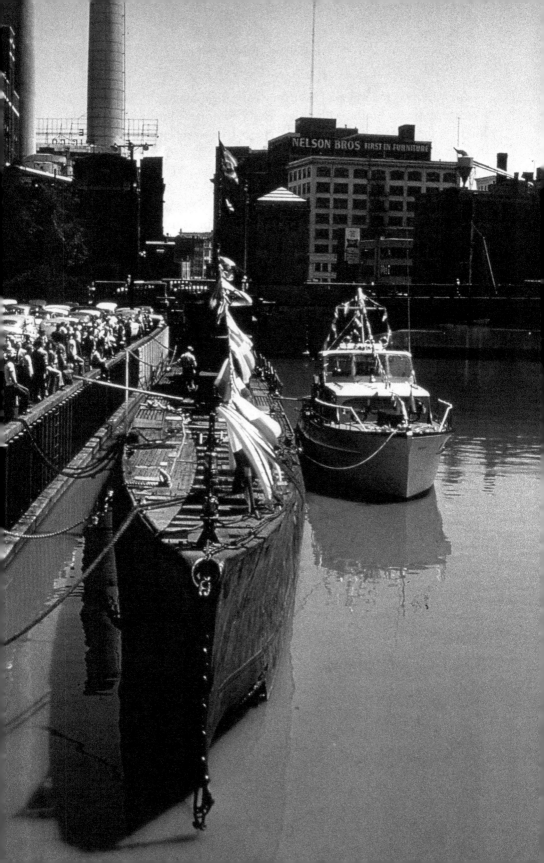

The yard was redeveloped over the years, beginning in 1998. There are barely any traces of the Milwaukee Road Railroad's former home today. In 2019, the Friends of Hank Aaron State Trail unveiled silhouette statues in the valley honoring the thousands of people who worked at the valley's shops and the extensive history of the Milwaukee Road from 1847 to 1985.

In 1958, German submarine *U-505* docked in Milwaukee. It was the first ship boarded and captured by the U.S. Navy since the War of 1812. It was en route to the Chicago Museum of Science and Industry, where, to this day, it is a permanent exhibit.

MAYFAIR MALL'S ICE CHALET

I n January 1973, Mayfair Mall in Wauwatosa, a suburb of Milwaukee, underwent a remodeling project to enclose the mall. The former Central Park area in the center of the facility was rebuilt as the Ice Chalet, a ten-thousand-square-foot skating rink.

Since opening on September 13, 1973, Mayfair Mall was predestined to become a tremendous success. The ice rink was located in the center of the mall and separated it into two sections. The comfortable fifty-five-degree-Fahrenheit air, complemented by beautiful music, dazzling lights and meticulously kept glass-like ice surface, guaranteed year-round enjoyment for skaters of every age and ability. Parents who brought their children ice skating for the first time at Mayfair Mall often commented on the pleasant chalet employees, as well as their eagerness to pass on information about skating. The rink was open every day of the year, with the exception of a few holidays. Many skaters expressed their enjoyment of their abilities through skating shows and exhibitions. There were always large crowds along the spectator railing and the indoor McDonald's windows in the middle of the summer and holiday seasons.

Skating has always been an affordable form of entertainment, and skating at Mayfair cost less than getting a babysitter. Parents often sent their kids off for a day of skating fun while they shopped. A quick, occasional check from the observation rail ensured the children were having a safe time.

When the rink was removed in March 1986 for a big expansion project, Mayfair Mall lost its unique charm, as the Ice Chalet made the mall more than just a shopping destination.

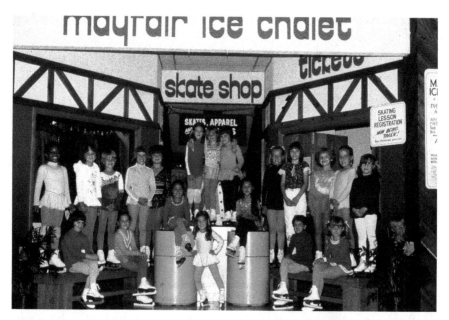

THIS PAGE AND FOLLOWING THREE PAGES The Mayfair Mall ice skating rink, 1982. *Slides donated by Dennis Ervin.*

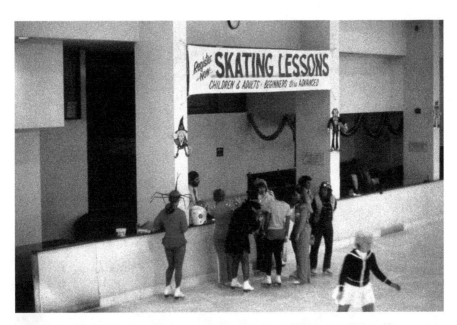

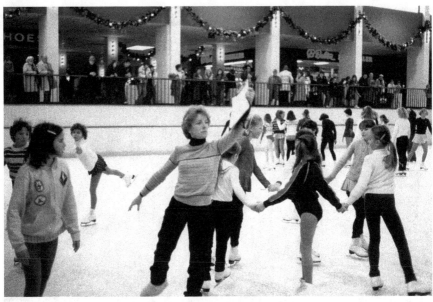

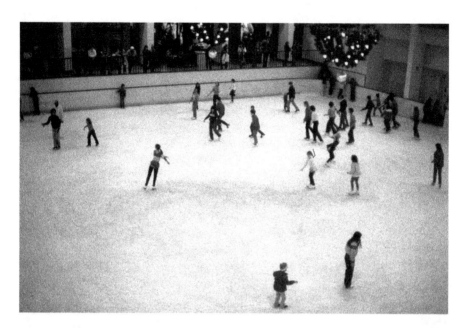

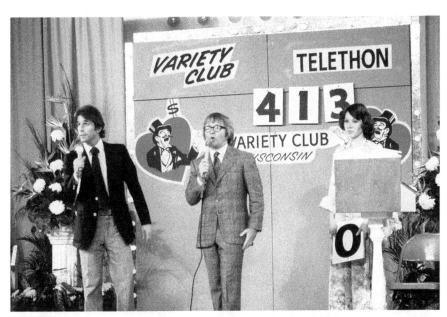

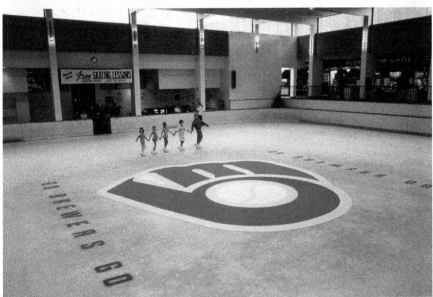

MILWAUKEE SIGNAGE

V intage signage, especially signage from Milwaukee, has a peculiar beauty and allure. This chapter is dedicated the vintage signage schemes throughout the city.

Lawrence J. Timmerman Airport, also known as Timmerman Field, is located on Milwaukee's northwest side on Hampton Avenue and Ninety-Second Street. Constructed in 1929, the airport continues to be utilized for general and private aviation. The airport was sold to airport manufacturer Curtiss-Wright Corporation in 1936 and renamed Curtiss-Wright Airport (or C-WC for short). C-WC was formed by the merger of companies founded by Glenn Curtiss, the inventor of naval aviation, and the Wright brothers, the pioneers who ushered in the era of aviation. The name gave the field a certain prestige, though it was unable to overcome the unfortunate effects of the Great Depression. Consequently, only one hangar was built. Curtiss-Wright Field was seen as a favorable site for Wisconsin air shows. The EAA also hosted the earliest Fly-In Conventions from 1953 to 1958.

Schroeder Used Books and Music was owned by John Schroeder. There were two locations on Wisconsin Avenue. The first bookstore, where this chapter's photograph was taken, opened at 807–9 West Wisconsin Avenue. In the mid-1960s, the building was destroyed by fire. Schroeder rebuilt the store at 636 West Wisconsin Avenue, and in the early '70s, he opened a second bookstore at 708 West Wisconsin Avenue. He sold cheap, used records and books, and you never knew what you might discover while browsing. Even though there was no organization in the stores, with piles

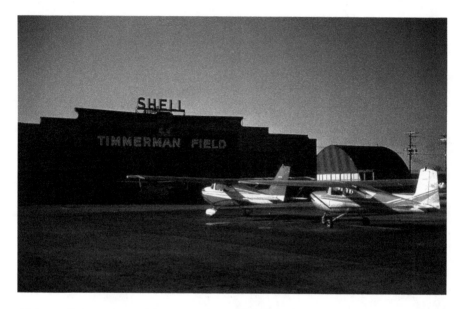

ABOVE Timmerman Field, 1961. *Unknown photographer, author collection.*

OPPOSITE Schroeder Books, 1972. *Jill-Koutroules-Bruss.*

of merchandise in the corners, they were great sources for growing record and book collections.

Oriental Drugs was located at the corner of North and Farwell Avenues in Milwaukee from 1928 to 1995. It was last operated by Hy Eglash starting in 1967 as a grocery/hardware store/corner drugstore with a four-bay lunch counter up front. The diner served simple Americana food. Citing the pressures of big-box chains and a skyrocketing drug pricing market, Eglash closed the location, and the purveyors that occupied the space afterward soon left no trace of what it once was. Oriental Drugs now lives on through photographs, Adolph Rosenblatt's signature sculptures, the documentary *Death of a Corner Store* and, of course, the signature T-shirts that read "I'm Hooked on Oriental Drugs."

The Oriental Theater has been an iconic landmark on Milwaukee's east side since 1927. Designed by Gustave A. Dick and Alex Bauer, the theater shows independent art films and Hollywood films. It also holds the world record for continuous showings of *The Rocky Horror Picture Show* as a Saturday midnight movie, which have been going strong since January 1978.

Hack's Furniture was established in 1935 as a small appliance store that grew to have several Milwaukee locations. The Hack's Furniture sign was

Hack's FURNITURE UNLIMITED

FURNITURE

- WAREHOUSE • SHOWROOMS
Selling Direct to the Public

Open 9:30 A.M. 9:00 P.M. Daily • Sundays Noon-5

PARKING • STORE ENTRANCE

SHIP

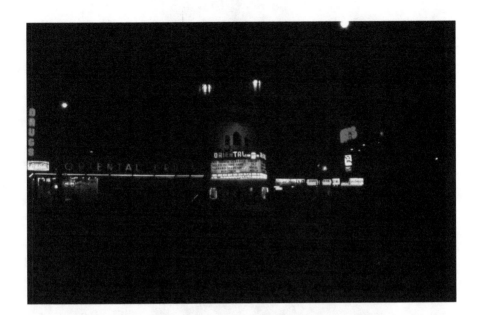

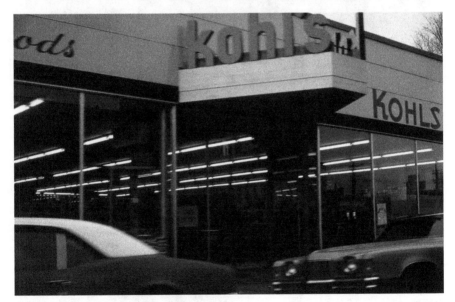

OPPOSITE Hack's Furniture, 1977. *John Aschon.*

THIS PAGE, TOP Oriental Theater, 1977. *Nancy Lynne Clothier.*

THIS PAGE, BOTTOM Kohl's Food Store at Forty-Seventh and Burleigh Streets, December 1972. *Jill-Koutroules-Bruss.*

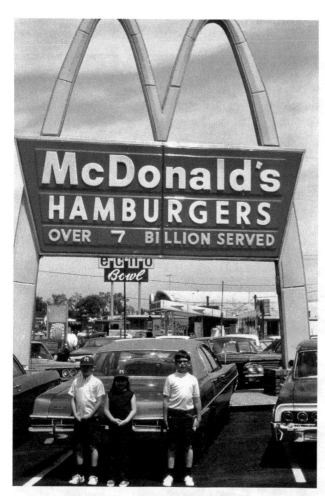

LEFT The
McDonald's in
Glendale, Wisconsin,
June 1971. *Sheldon
Berson.*

BELOW Schlitz
Brewery, 1972.
*Unknown
photographer,
author collection.*

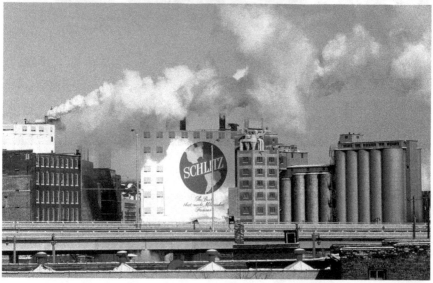

painted on the vast exterior Cream City brick walls of the Pritzlaff building on Plankinton Avenue, which was home to Hack's Furniture until 1984.

Starting in 1927, Max Kohl operated grocery stores in Milwaukee. In 1946, he built his own grocery store, which grew to be the largest supermarket chain in Milwaukee. This chapter's image of Kohl's was taken in 1972. The store was located on Forty-Seventh and Burleigh Streets and was a big deal in the neighborhood. It was the first full-sized "supermarket" in Milwaukee. It had a bakery and flowers, along with all the other things you could possibly need. The store was permanently closed in 2003.

This photograph of a McDonald's sign was taken in Glendale in June 1971. The incredible signage on Port Washington Road may bring back fond memories of the Echo Bowl, a big hangout for most people who lived in the North Shore; Clark Super 100 gas station, where gas cost less than one dollar; and Arthur Treacher's Fish and Chips.

German immigrant Joseph Schlitz moved to Milwaukee and ran a small brewery that eventually became the nationally distributed Schlitz Brewing Company.

CAPITOL COURT
SHOPPING CENTER

O n August 30, 1956, Capitol Court, a "state-of-the art" outdoor shopping center, opened in Milwaukee at the intersections of Capitol Drive, Sixtieth Street and Fond du Lac Avenue. Comprising over fifty-seven acres, it was one of the first shopping centers in the area with a vast parking area. This chapter's vibrant images of Capitol Court were given to Gino Salomone when the mall permanently closed in the late 1990s. Gino kindly allowed the images to appear in this book.

On Capitol Court's opening day, sixty stores were opened for business. The anchor stores were T.A. Chapman's and Schuster's. Its major retailers included JCPenney, Woolworth's, Chandler Shoes, Baker Shoes, Walgreen's, Hobby Horse, Johnny Walker's Men's Shop, Schmitt-Orlow and Fanny Farmer Candy. Its local retailers included Singer's, Rosenberg's, Field's, Spic & Span and Fritzel's. A lower level, accessible by stairs, included several smaller shops and a café. Over the years, stores were replaced by Gimbel's, Boston Store, Target and Dunham's.

Many Milwaukeeans have fond memories of the mall's seasonal attractions, such as the Kooky Cookie House, the giant Christmas tree surrounded by candy canes in the center court (Candy Cane Lane), the giant Easter egg, a petting zoo, Monkey House, Funtown/Kiddietown and, later, a miniature golf course. In 1964, the one-screen Capitol Court Theatre opened, "designed to be the finest in Wisconsin."

In 1978, the shopping center was enclosed, and by 2001, the Capitol Court Mall had been demolished and replaced by Midtown Center.

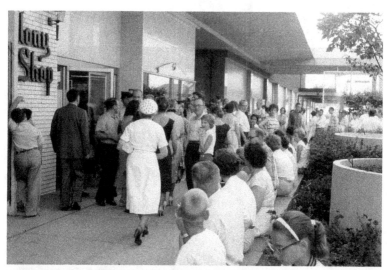

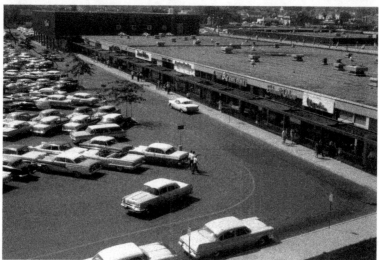

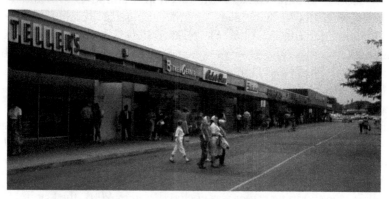

THIS PAGE AND FOLLOWING THREE PAGES Capitol Court, 1956.
Gino Salomone.

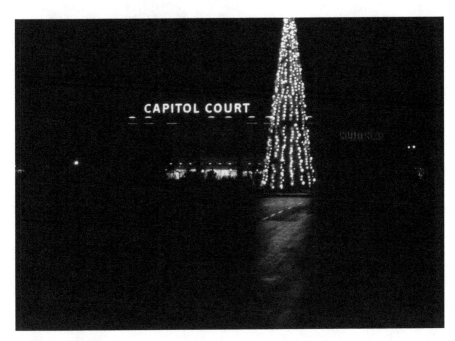

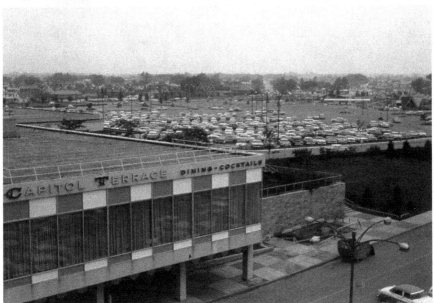

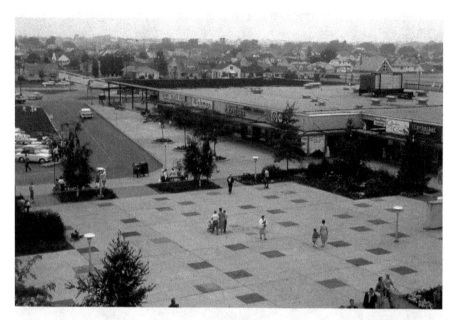

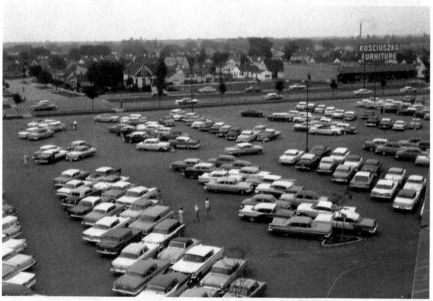

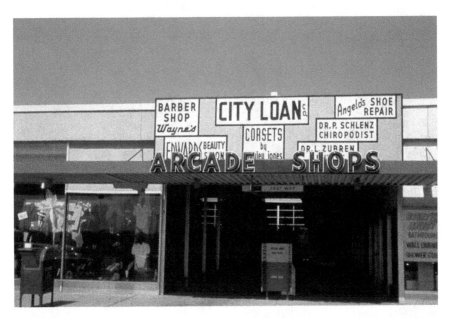

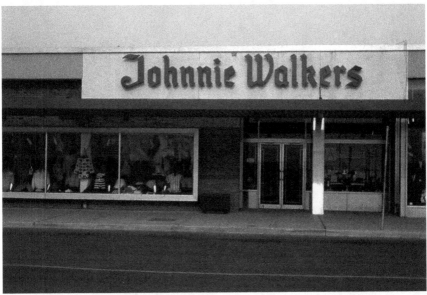

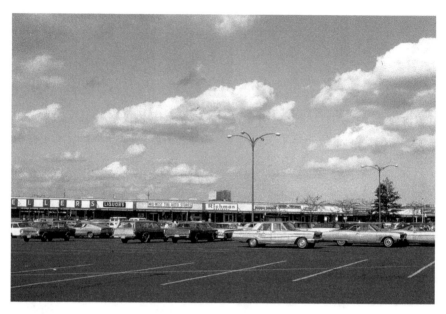

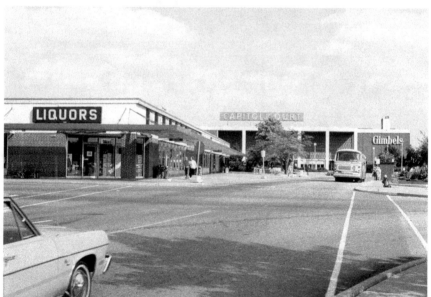

THIS PAGE, TOP Capitol Court, 1970. *Gino Salomone.*

THIS PAGE, BOTTOM, AND OPPOSITE Capitol Court, 1976. *Gino Salomone.*

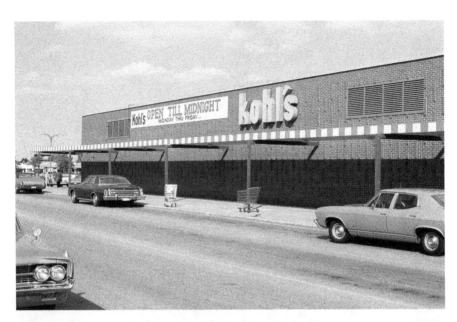

1950s MILWAUKEE COUNTY STADIUM

Milwaukee County Stadium was the epitome of a ballpark. The greatest players of the second half of the twentieth century played on this field. The Milwaukee Braves broke league attendance records there, and in its time, fans witnessed the team win both National and American League pennants, two All-Star Games and three World Series and Vince Lombardi's Green Bay Packers dominate professional football.

County Stadium was born from the prosperity and optimism of the post–World War II era. Milwaukee was a growing city on a Great Lake with rich ethnic diversity, manufacturing muscle and famous beer. On October 19, 1950, ground was broken for County Stadium. By March 1, 1953, it was finished at a cost of roughly $6.5 million. At the time construction began, the stadium had no tenant, and community leaders hoped it would attract a Major League franchise, even though there was no prospect of league expansion and no team had moved in decades. There were sixteen teams in the league, and nobody thought, at that point, that a team would leave the East Coast and move to Milwaukee. Nevertheless, on March 13, Boston Braves owner Lou Perini announced his intention to move the team to Milwaukee. On March 18, National League owners approved the move, and the Milwaukee Braves were born.

The following season, 2.1 million fans walked through the turnstiles at County Stadium. In the early 1960s, the Braves began to slip in the league's standings—and so did attendance. In 1962, attendance fell below 800,000, and Lew Perini decided to sell the team to a group of Chicago businessmen. Rumors of a move to Atlanta followed in late 1963. The next year, the team's move to Atlanta was approved, but the team was ordered to stay in

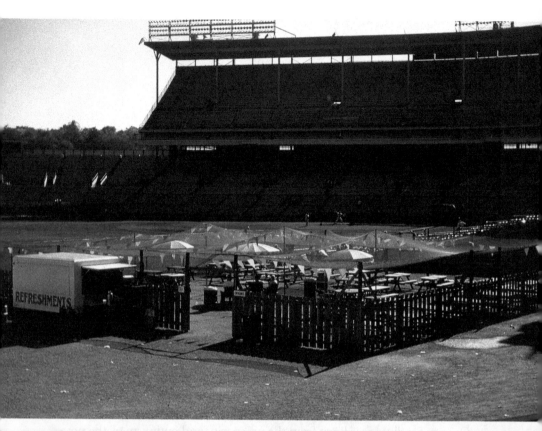

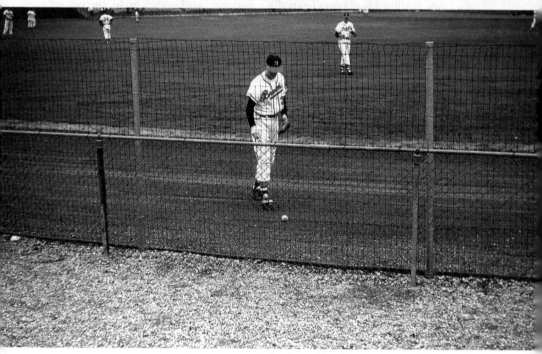

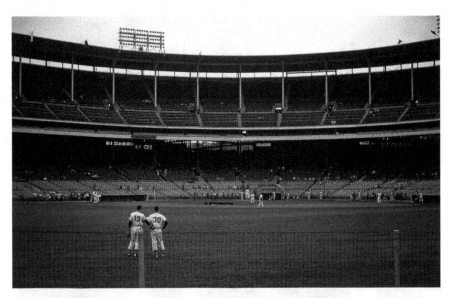

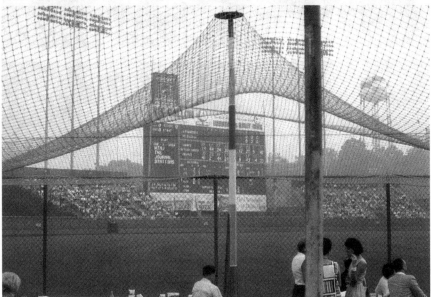

OPPOSITE, TOP The County Stadium picnic area, 1960. *Unknown photographer, author collection.*

OPPOSITE, BOTTOM A player in the outfield at County Stadium, July 10, 1956. *Unknown photographer, author collection.*

THIS PAGE, TOP A view of center field at County Stadium, July 10, 1956. *Unknown photographer, author collection.*

THIS PAGE, BOTTOM County Stadium's scoreboard in the daytime, July 15, 1964. *Unknown photographer, author collection.*

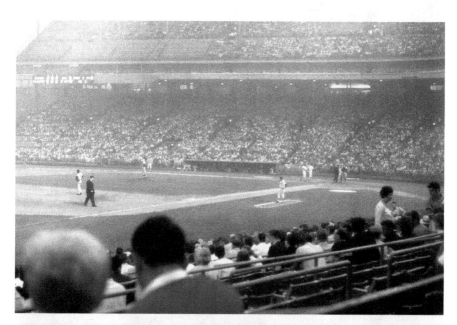

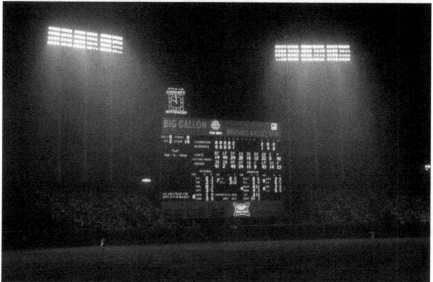

THIS PAGE, TOP County Stadium's third base side, July 15, 1964. *Unknown photographer, author collection.*

THIS PAGE, BOTTOM County Stadium's scoreboard at night, July 15, 1964. *Unknown photographer, author collection.*

OPPOSITE County Stadium's first base side, July 15, 1964. *Unknown photographer, author collection.*

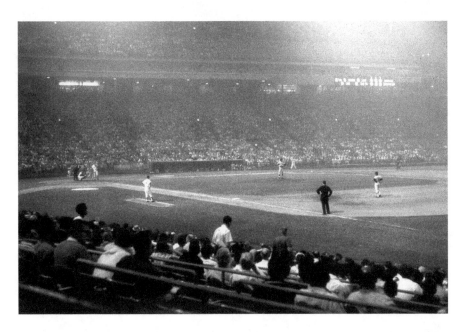

Milwaukee for the 1965 season. A total of 12,000 fans attended the Braves' final home game at County Stadium on September 22, 1965. There were a few standing ovations, but there was little to cheer about.

County Stadium was demolished in February 2000. Between its opening in 1953 and its closure, the park hosted more than 100 million spectators who enjoyed various events.

ABOUT THE AUTHOR

A s a curator of the Old Milwaukee Facebook group, Adam Levin has provided Milwaukeeans with the preservation of and access to photographs and tidbits of the past, which helps them appreciate the rich history of Cream City. After school, Adam found employment at K&S Photographics, where he processed and developed commercial film. Despite the enjoyment he received from this line of work, he chose a different career path that resulted in him putting his true passion temporarily on hold. Nearly fifteen years later, in 2012, his passion was reignited. In fact, it became an obsession. Marrying his fascination with history and love for photography, he set out on a new path. While he initially focused his rebirthed hobby on historic architecture, he incidentally discovered a new love inscribed on those walls: ghost signs. In 2016, he briefly left Milwaukee, relocating to New Jersey for approximately two years. This proximity to New York City gave him the opportunity to explore the wondrous nooks and crannies of the city, using every adventure as another opportunity to continue honing his photography skills. In February 2020, he released a book through The History Press called *Fading Ads of Milwaukee*, which showcases Milwaukee ghost signs.

When Adam is not photographing building demolitions or newly revealed signs, he is often perusing old photographs, 8 mm films and 35 mm Kodachrome slides of Milwaukee and the country of bygone eras at local antique stores and estate sales.